EMPTY PLACES

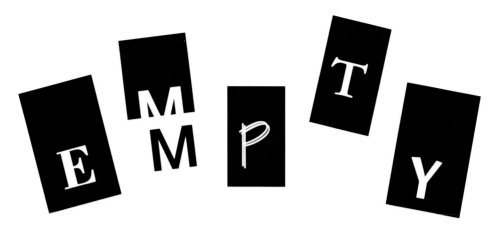

EMPTY

PLACES

a performance
Laurie Anderson

HarperPerennial

A Division of HarperCollinsPublishers

FIRST EDITION

Designed by: Carolyn Cannon
Production Assistance: Lisa Shafir

Library of Congress Cataloging-in-Publication Data

Anderson, Laurie, 1947—
Empty Places : a performance / Laurie Anderson.
— 1st HarperPerennial ed.
 p. cm.
 ISBN 0-06-096586-X (paper)
 1. Anderson, Laurie, 1947– . 2. Performance art— United States.
I. Title.
NX512.A54A4 1991
700' .92—dc20 90-56419

91 92 93 94 95 CS/CW 10 9 8 7 6 5 4 3 2 1

CONTENTS

Violin Solo

My Eyes

Politics and Music

So Good Night Ladies

I See by Your Outfit

Speaking Japanese

National Anthem A and B

Coolsville

These Rules

Duet with Dogs

Lolita

The National Debt

Pobre Mexico

Hiawatha

Budapest, December 10, 1990

The Wall

Large Black Dick

Parade

Listen Honey...

Grils

Beautiful Red Dress

Shadow Box

Last Night

Strange Angels

More Strange Angels

Brilliant Pebbles

Ramon

Falling

About *Empty Places*

Violin Solo

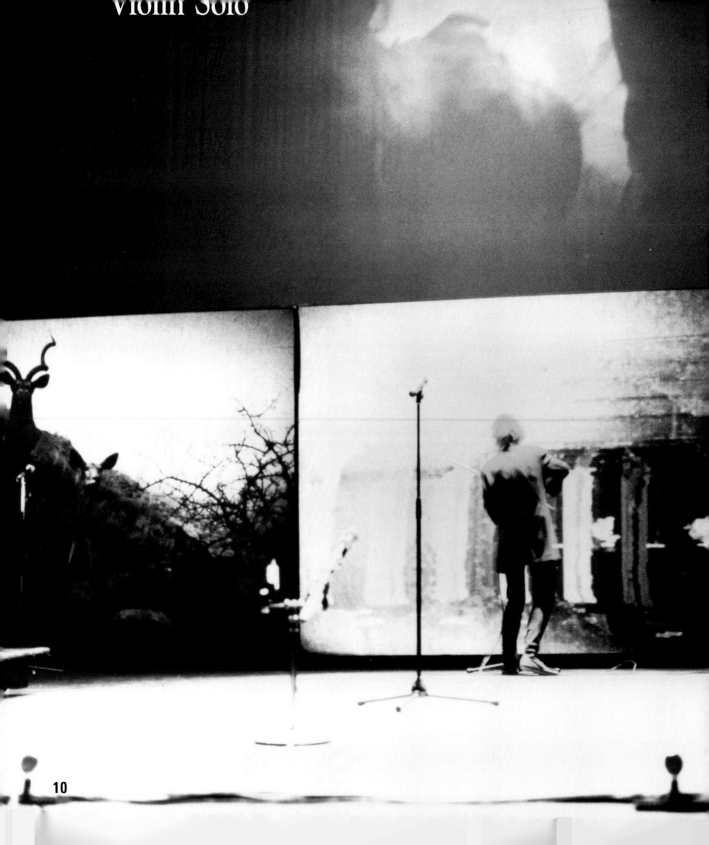

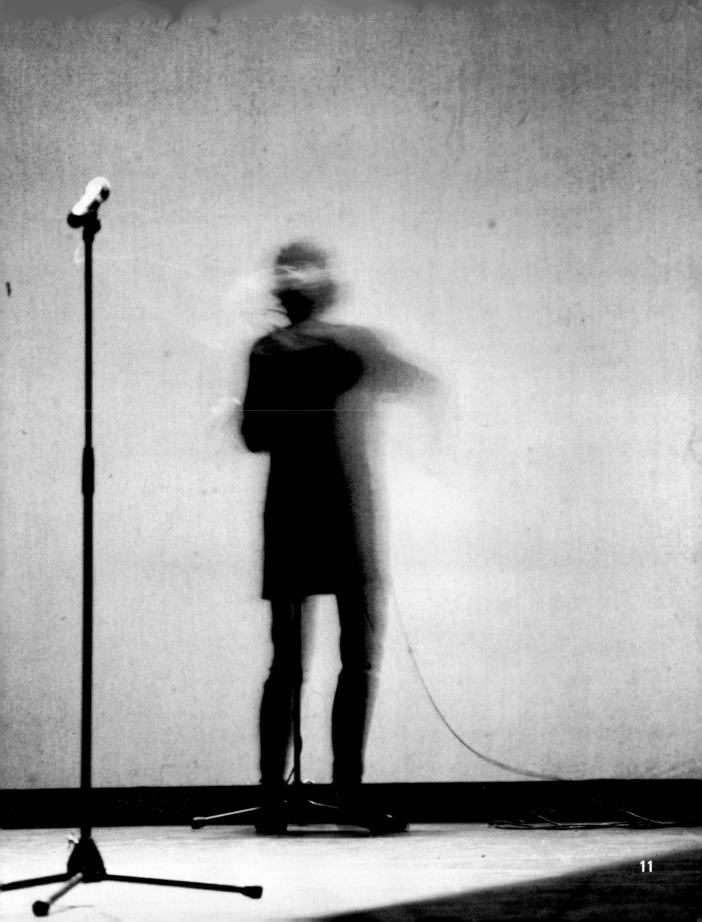

My Eyes

Sometimes I wish I hadn't gotten that tattoo.
Sometimes I wish I'd married you.
One hundred fires. One hundred days.
Sometimes I feel like a stranger.
Sometimes I tell lies.
Whoa ho! Sometimes I act like a monkey.
Here comes the night.

And then kerjillions of stars start to shine.
And icy comets go whizzing by.
And everything's shaking with a strange delight.
And here it is: the enormous night.
And oo my eyes!
They're lookin all around. And oo my feet!
I'm upside down.

If I were the president. If I were queen for a day
I'd give the ugly people all the money.
I'd rewrite the book of love —
I'd make it funny.
Wheel of fortune. Wheel of fame.
Two hundred forty million voices.
Two hundred forty million names.

And down in the ocean where nobody goes
Some fish are fast. Some are slow.
Some swim round the world. Some hide below.
This is the ocean.
So deep.
So old.

And then kerjillions of stars start to shine.
And icy comets go whizzing by.
And everything's shaking with a strange delight.
And this is it: the enormous night.
And oo my eyes!
They're lookin all around.
And oo my feet!
They've left the ground.

So cry me a river that leads to a road
that turns into a highway that goes and goes
and tangles in your memories:
So long. So old. And oo my eyes!
They're lookin all around. And oo my feet!
They've left the ground.

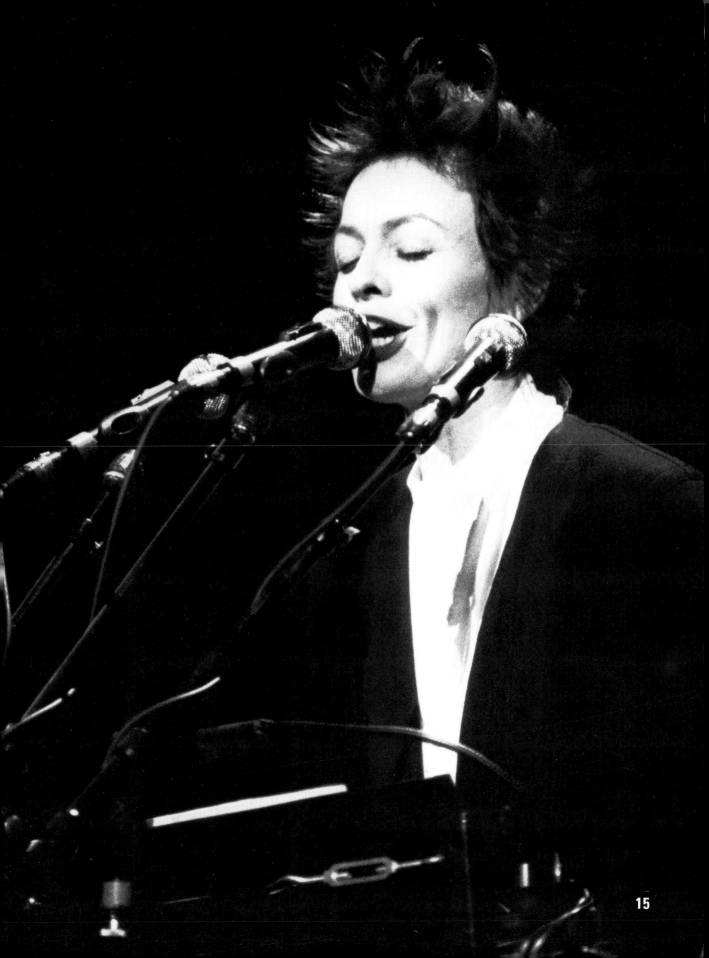

POLITICS

&

Good evening.
Tonight's topics are politics and music.
Now there are those who say that politics and art
just don't mix.
But before we begin, I just want to say a word about
Sonny Bono. I mean the guy bothers me.
Ever since he was elected mayor
of Palm Springs,
it seems like singing politicians are everywhere.

I do have to say, however, I was happy to learn
that the singer Alice Cooper is still running
for office and he's got a really great slogan.
His slogan is:

"A troubled man for troubled times."

Now he's got my vote on that slogan alone.

But of course now that so many singers
are doing politics,
a lot of politicians are starting to sing.
And lately it's been a really great time to study
the political art song format.

I mean, just how do people convince each other of things
that are basically quite preposterous?
It's an art form. Listen carefully, and you discover these aren't speeches at all —
but quite sophisticated musical compositions.

Now take a guy like Hitler. You listen to his speeches.
They're all rhythm — no pitch. I mean Hitler was a drummer.
A really good drummer.
And he'd always start with a really simple
kick/snare idea. You know:

BOOM CHICK! BOOM CHICK!!
BOOM CHICK! BOOM CHICK!!

He'd lay down this really solid groove and people would start —
moving to it.
And then he'd add a few variations:

BABABA BOOM CHICK
BABABA BOOM CHICK
BABACHICK BOOM CHICK!!

And then he'd take a really wild solo and they'd all be yelling and dancing.
YEAH!
Now don't forget these were the people who invented the Christmas tree.
So in their minds, see, there's this fir tree out in the forest and they say:
YA! This tree must be inside the house!
We must go get it and bring it *inside* the house.
Inside! Inside!

They've got this thing about nature
and it's the same with music.
They've got to *do* something with it.
They've got to bring it on home.

So they're stompin and movin and groovin
and their feet are all synched up to those drums
and they're moving like one giant thing.
And pretty soon they've got to go somewhere
they've got to get out
they've got to go someplace
like Poland.

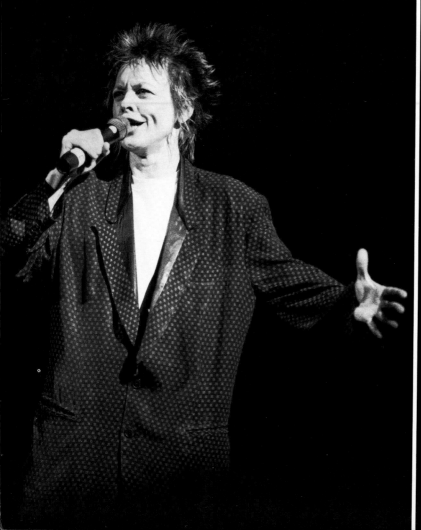
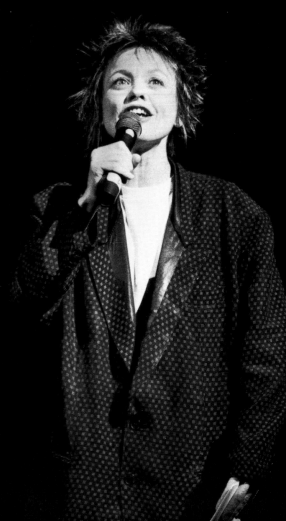

Or take Mussolini. You listen to his speeches.
And he's singing grand opera.
Doing all the parts. And he's hitting all those hard-to-reach
high notes.

FRONTIERE! FRONTIERE!

He was always singing about the frontier.
And all those fans with their ham sandwiches
up in the third mezzanine are going nuts
and it goes on for hours and hours.
Yeah, they go wild, those opera fans!

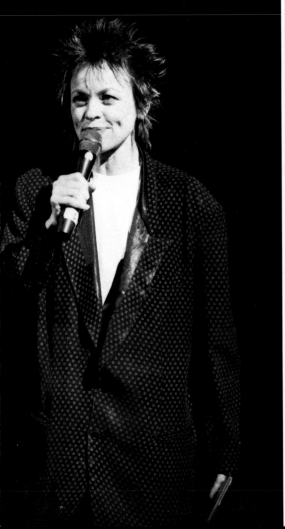
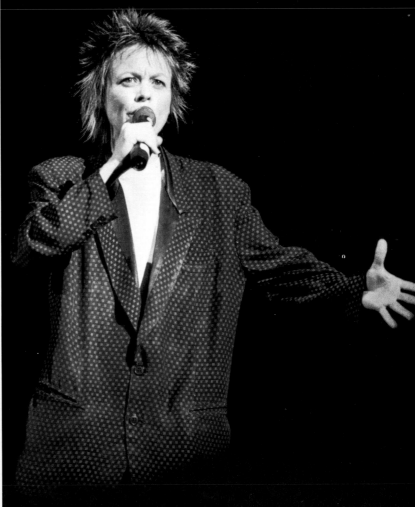

But of course the all-time American master of this art form was
Ron Reagan. And when Reagan wanted to make a point,
he would lean right into the mic
and get softer
and softer
until he was talking like
this.
And the more important it was,
the softer
and the more intimate
it would get.

With lots
and lots of
pauses.
Like he was trying to remember something that happened
a long time ago.
But he could never really *quite* put his
finger on it.

And when he talked
he was singing to you.
And what he was singing was

"When You Wish Upon a Star."

So Good Night Ladies

So good night ladies. And good night gentlemen
Drive safely now.
And please don't call again.
And when you wake up,
you little sleepy heads,
get up! get up! get up! Get out of bed!
Take a look around. Walk out your door.
Breathe in that new morning.

That's right. Things are pretty different now.
Now that people finally realize
it's OK
to have it all.
Sure there are a few stragglers.
There's some yelling going on.
Things like:

"YOU JERK"

or

"GET OUT
OF MY
FUCKING
NEIGHBORHOOD!"

But hey, it's a free country.
And in conclusion,
I'd like to sing a short song —
it's one of my favorites.
Goes something like this:

I See by Your Outfit

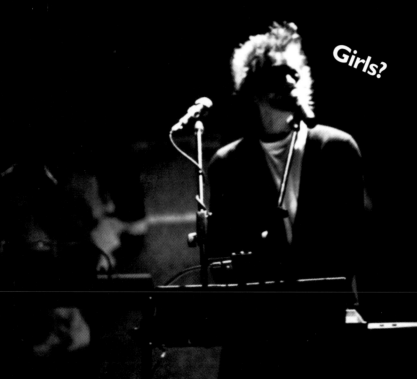

Girls?

(male voice)
Ooo oo oo oo oo oo ooo oo oo oo
I see by your outfit
that you are a cowboy.

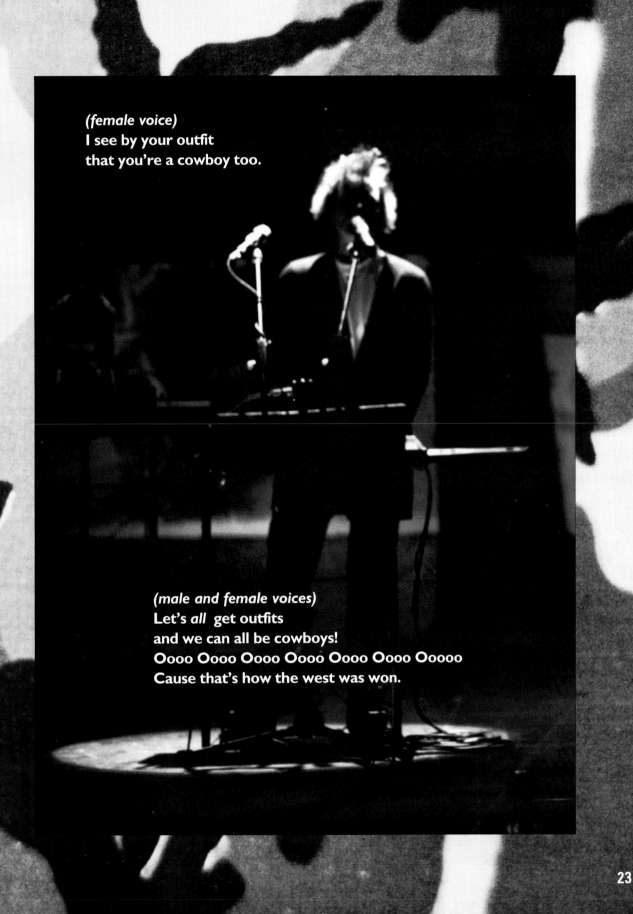

(female voice)
I see by your outfit
that you're a cowboy too.

(male and female voices)
Let's *all* get outfits
and we can all be cowboys!
Oooo Oooo Oooo Oooo Oooo Oooo Ooooo
Cause that's how the west was won.

Speaking Japanese

A couple of years ago I did some concerts in Japan
and I decided to sing all the songs in Japanese.
So I learned them phonetically
and it took a couple of months—
but I was pretty proud of myself.

Then after the concert the Japanese promoter
came backstage and said:
"Excuse me. Pardon me,
but you seem to speak English
really well but excuse me, pardon me,
in Japanese you have a slight
stutter."

I couldn't believe it!
Later I discovered that the guy
who had recorded the cassette for me
had a slight st-st-stutter
and I'd copied everything perfectly,
carefully noting that *this* particular word was
ts-ts-tsuru
and this other was
ts-TZ-tsuru.

Anyway it was impossible to unlearn any of the songs
because the st-stuttering had become so much a part of the
r-r-r-hythm of m-m-my m-m-usic.
The worst part though was that I seemed to have picked up
a pretty much permanent stutter in Japanese,
which makes it especially hard if you work with electronics.
I mean I go into a local outlet and ask:

So have you got the new S-s-s-ssony R-r-r-r-rrrrrDAT in yet?
And what about the new Ya-aa-ama-aa-aha-aaa keyboard?
And what's new from M-M-Mitsubishi,
Hita-ta-ta-tatachi
and Naka-naka-na-aaaaaka-
michi?

And I said: On second thought, do you still carry any of that American equipment?

National Anthem A and B

You know, I'd have to say my all-time favorite song is probably
the national anthem. It is hard to sing though, with all those arpeggios.
I mean you're out at the ballpark and the fans are singing away
and it's sort of pathetic watching them try to hang on to that
melody.

The words are great though — just a lot of questions written during a
fire. Things like:

Q.

Hey! Do you see anything over there?

A.

*I dunno . . .
there's a lot of smoke.*

Q.

Say! Isn't that a flag?

A.

*Hmmm . . . couldn't say really,
it's pretty early in the morning.*

Q.

*Hey!
Do you smell something burning?*

I mean that's the whole song!
It's a big improvement over most national anthems though,
which are in 4/4 time:

*"We're number one!
This is the best place!"*

I also like the B side of the national anthem —
Yankee Doodle.
Truly a surrealist masterpiece.

"Yankee Doodle came to town.
Riding on a pony.
Stuck a feather in his hat
And called it macaroni."

Now, if you can understand *this* song,
you can understand anything
that's happening in the avant-garde
today.

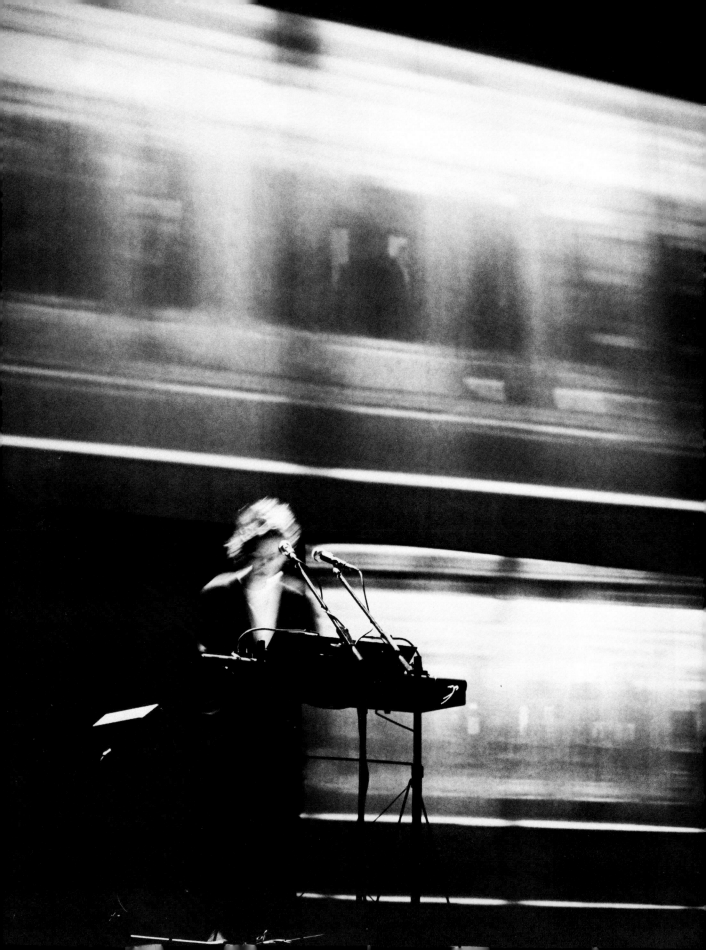

COOLSVILLE

Coolsville. Cooooolsville.
So perfect. So nice.
Hey little darlin. I'm comin your way, little darlin.
And I'll be there. Just as soon as I'm all straightened out.
Yeah. Just as soon as I'm
perfect.

Some things are just pictures.
They're scenes before your eyes.
Don't look now!
I'm right behind you.
Coolsville. Coolsville.
So perfect. So nice.
So nice!

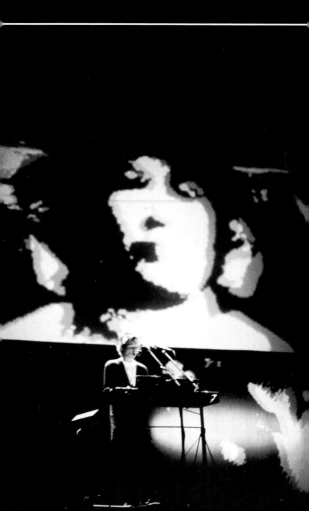

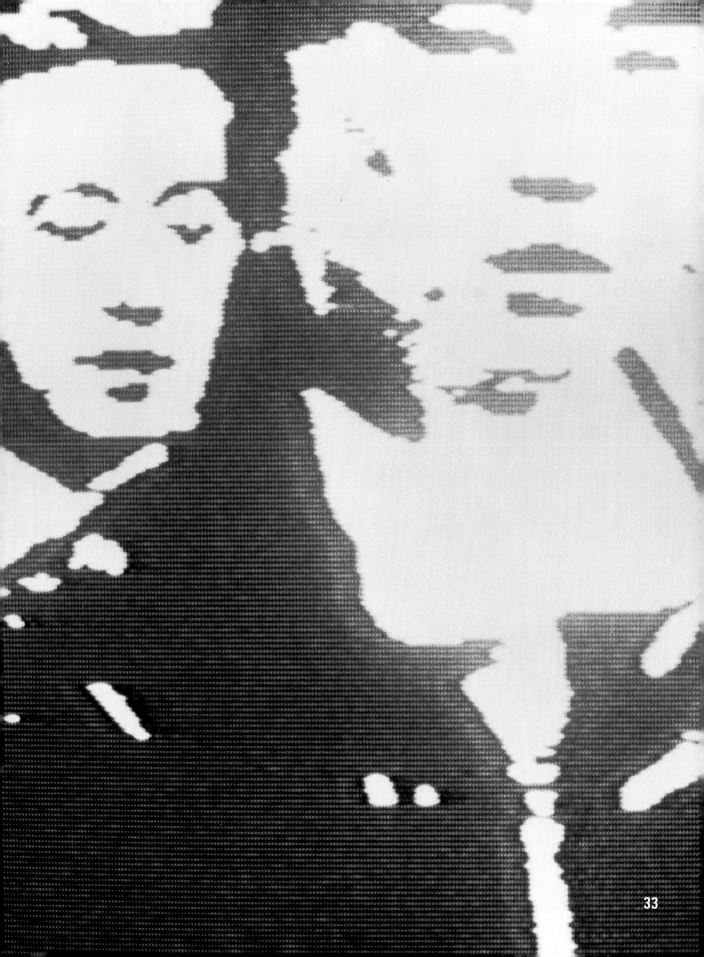

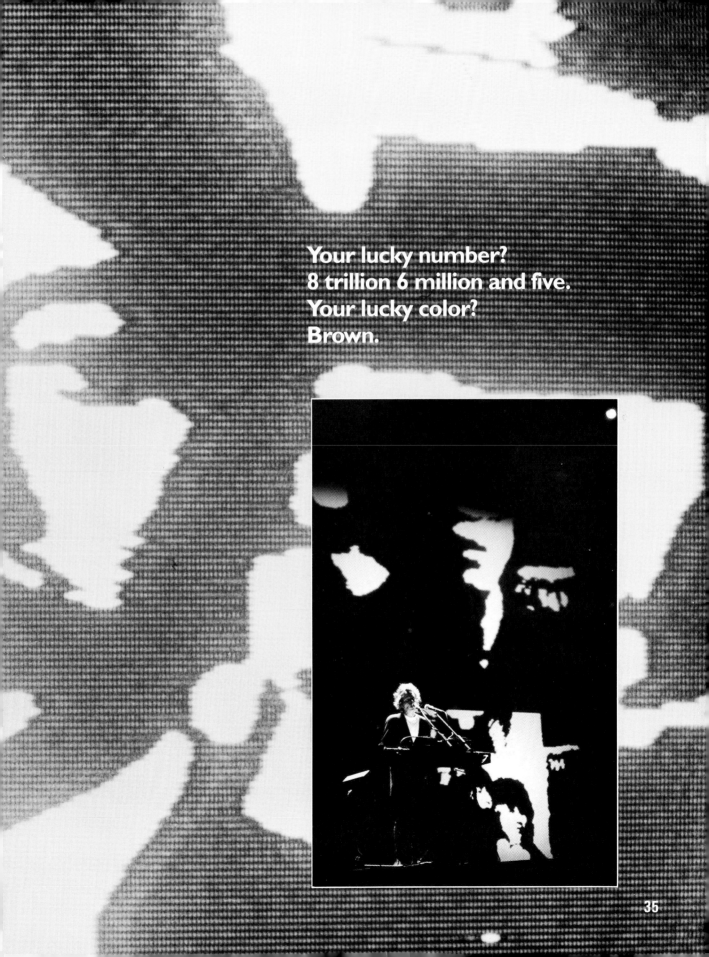

Your lucky number?
8 trillion 6 million and five.
Your lucky color?
Brown.

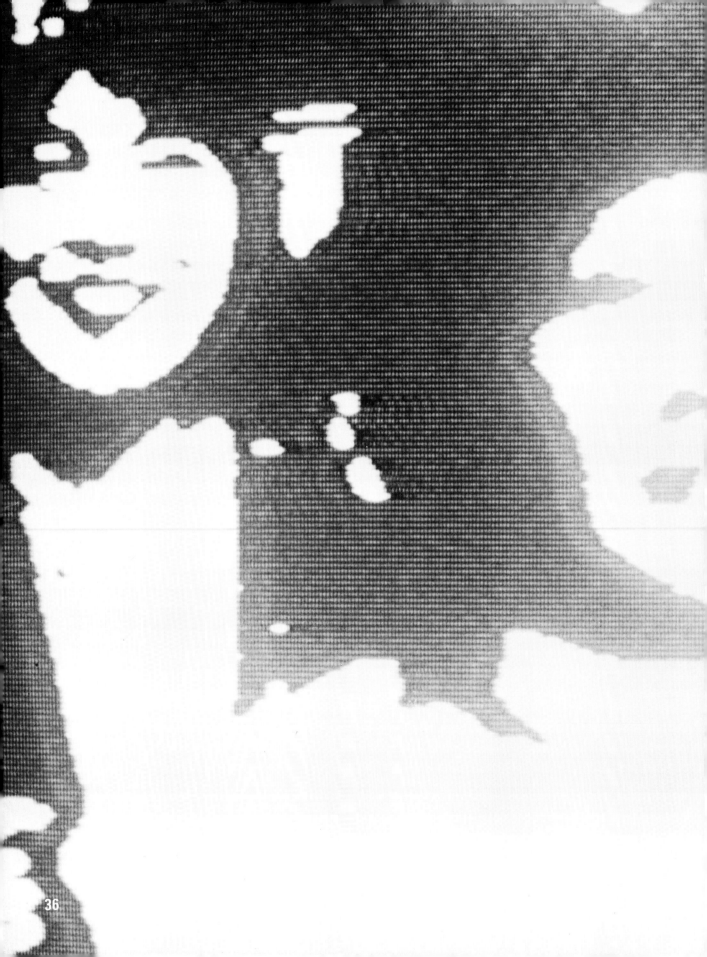

And down by the ocean
Under the boardwalk
You were so handsome
We didn't talk. You're my ideal.
I'm gonna find you. I'm goin to Coolsvil
So perfect. So ideal.
This train. This city. This train.

Some things are just pictures.
They're scenes before your eyes.
And don't look now!
I'm right behind you.
Coolsville.

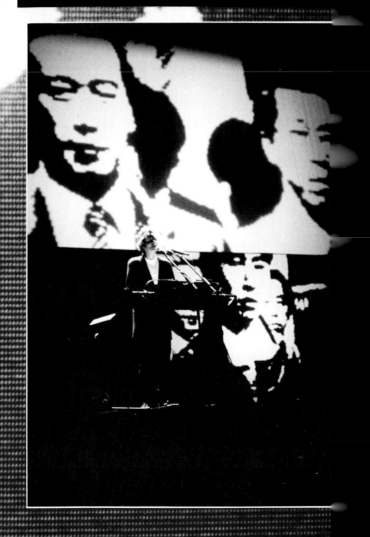

She said: Oh Jesus!
Why are you always in the arms
of somebody else?
He said: Oh man!
I don't need anybody's help.
I'm gonna get there
on my own.

This train. This city. This train.
This city. This train.

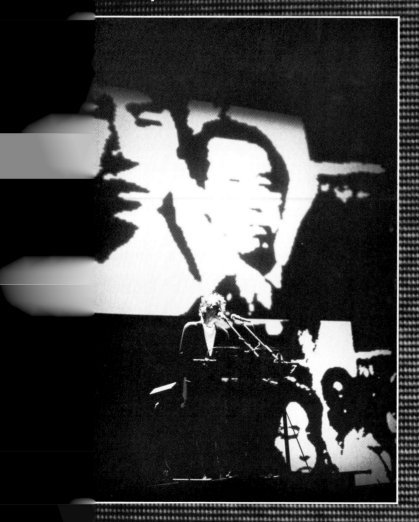

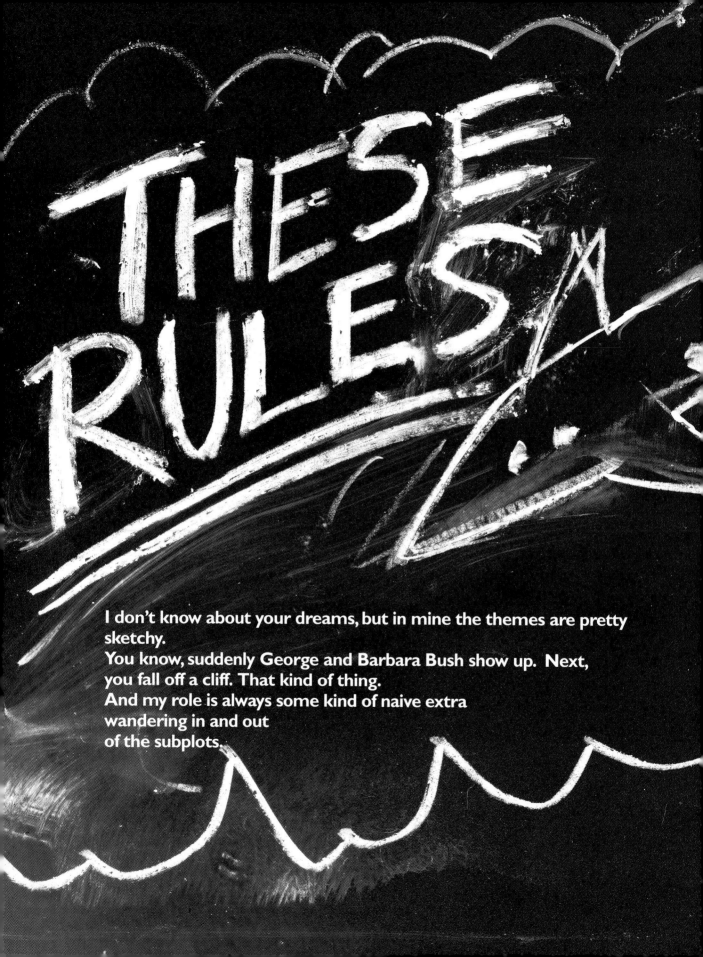

THESE RULES

I don't know about your dreams, but in mine the themes are pretty sketchy.
You know, suddenly George and Barbara Bush show up. Next,
you fall off a cliff. That kind of thing.
And my role is always some kind of naive extra
wandering in and out
of the subplots.

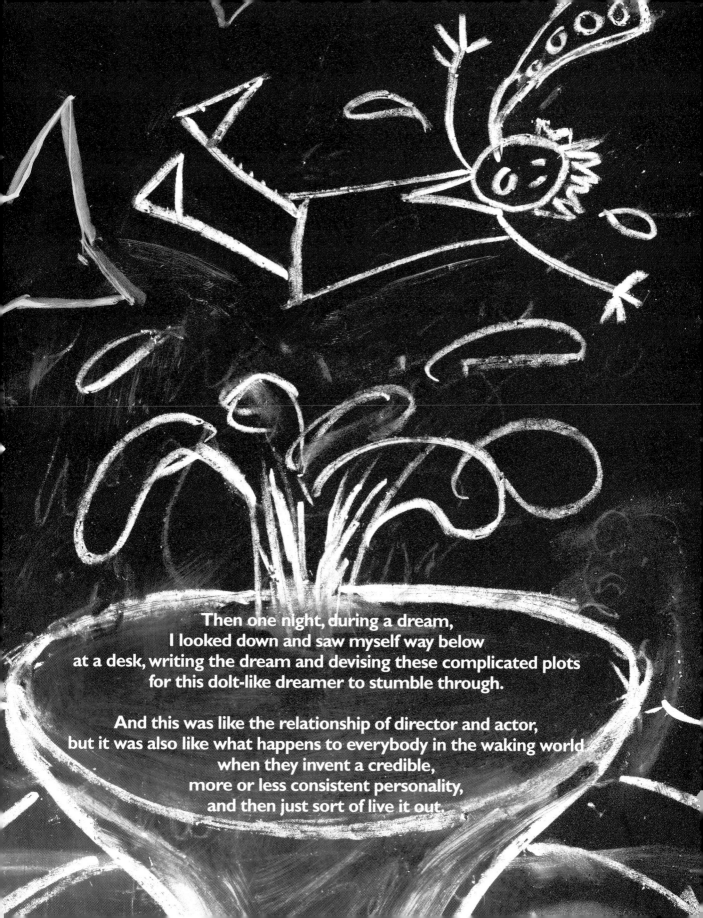

Then one night, during a dream,
I looked down and saw myself way below
at a desk, writing the dream and devising these complicated plots
for this dolt-like dreamer to stumble through.

And this was like the relationship of director and actor,
but it was also like what happens to everybody in the waking world
when they invent a credible,
more or less consistent personality,
and then just sort of live it out.

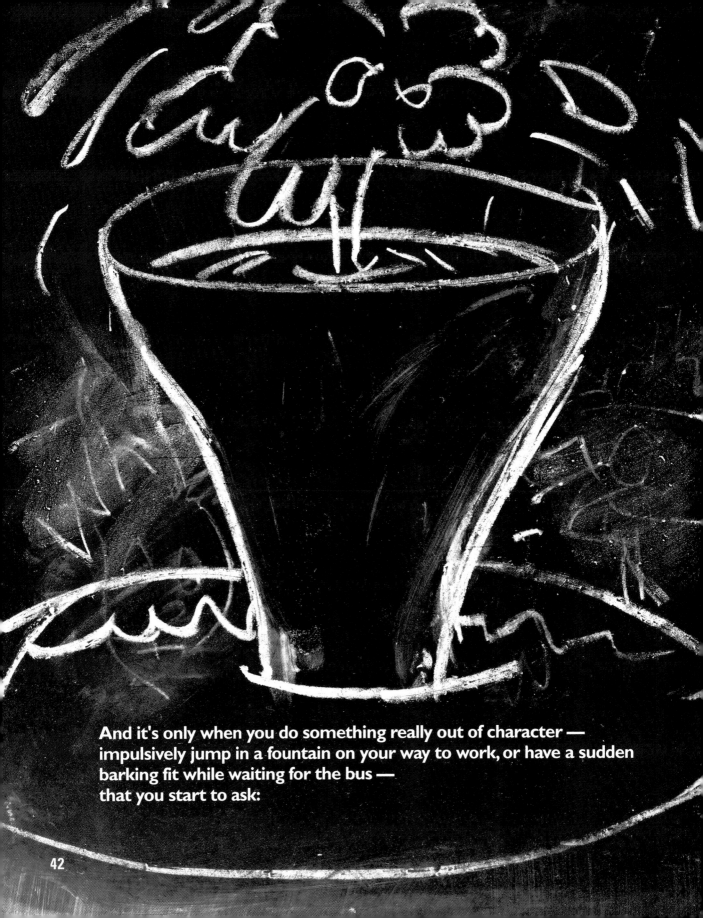

And it's only when you do something really out of character —
impulsively jump in a fountain on your way to work, or have a sudden
barking fit while waiting for the bus —
that you start to ask:

Who wrote
this anyway?
Who wrote
these Rules?

I'll tell you who wrote these rules.
Mrs. Tjell.
Who's Mrs. Tjell?
She was our second grade schoolteacher.
And she would tell us these endless stories
and each sentence would set up
a completely different scene from the one before.
They would go like:
One fine morning the gray rabbit woke up.
Mr. Edwards was going to go down to the farm.
But the chickens and the rabbits
were out for a drive.
Then little Barbara was crying: Oh no!

44

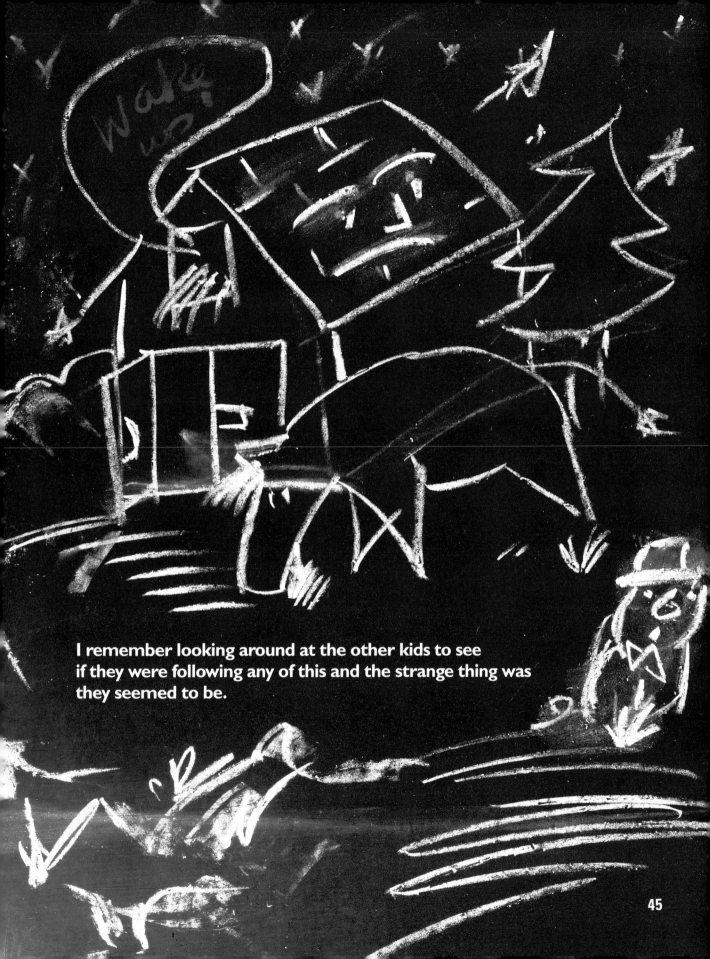

I remember looking around at the other kids to see
if they were following any of this and the strange thing was
they seemed to be.

Duet with Dogs

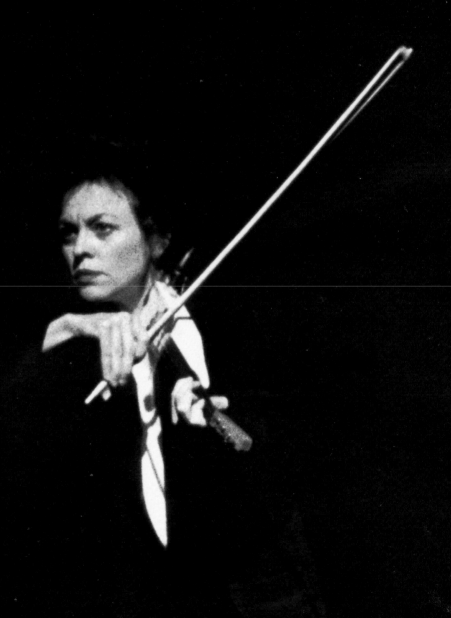

Lolita

You know there's a really strange animal
out at the Bronx Zoo
in the exhibition called "The World of Darkness."
And it has the head of a mouse
and the body of a miniature deer
with tiny deer hooves.
And it's an actual animal
not something manufactured in a lab.
And the label posted on the display says:
DEER/MOUSE.

It's like those ads you see sometimes in the newspaper for

DEER

"Yeah well see it's this way.
I'm a mouse but I just *work* as a mouse, days.
It's a job.
But what I really am
is a deer.
Or that's what I'd like to be someday.
That's my aspiration. Knock on wood."

MOUSE

49

GIRLS?

Hoo doo doo doo doo doo.
Hoo doo doo doo doo doo doo.
Hey lady! **HEY LADY!!** Come to my room.
I've got something to show you.
Who me??
I've got something really nice to show you.
Pull up a chair.
Oooo mein Herr! GIRLS?
Hoo doo doo doo doo doo.
Hoo doo doo doo doo doo doo.

Hey remember when the tall ships came in?
That big parade up the Hudson River
of all the navies of the world?
And the gay guys from the west side
decided in the spirit of international relations
to have a bake sale.
So they dressed up in tiny little sailor suits.
Ooooo short shorts!
So when all the sailors got off their boats —
the Swedes, the Russians, the Finns, the French —
the first thing they heard was:
WELCOME! Welcome to the land of the free!
Have a cupcake.

GIRLS?

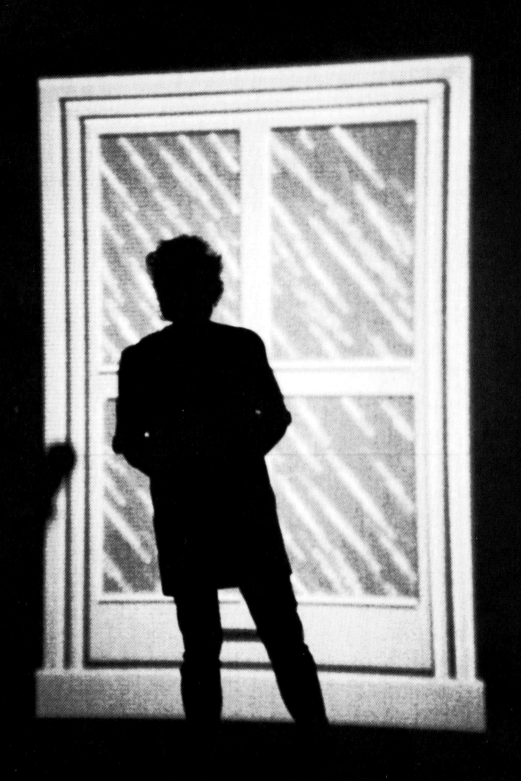

Single white female. Loves J.S. Bach.
Long walks. Guys named Steve.
Please don't send a photo —
Oil paintings only, please.

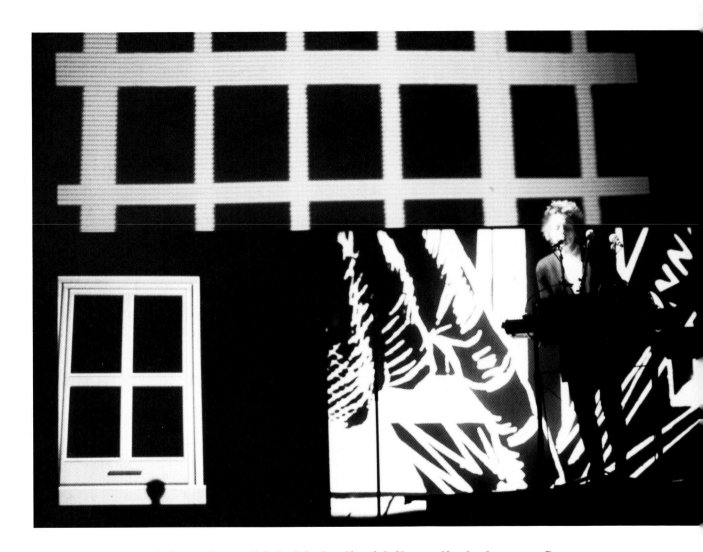

Ah Lolita! Light of my life! Ah Lolita! Like a little butterfly.
Oooo I love those tiny little feet. Here she comes.
Hey big buddy! Hey big fat daddy!

The National Debt

You know recently I've started to get pretty worried
about the American national debt,
which is rising at the hair-raising rate of eight thousand dollars
per second.
By the end of this evening's performance, for example,
it will have gone up another thirty-six million.

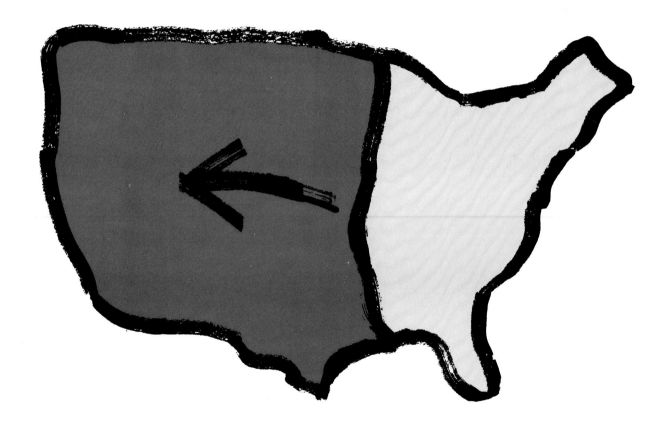

Now as most of you probably know,
at this moment all the taxes west of the Mississippi River
go exclusively towards paying the interest
on the national debt.

Now if the numbers continue to escalate at this rate,
and given the inflation on current interest rates, by the year 2020,
all the taxpayers west of the Amtrak corridor
will be paying off the interest
on the national debt.

This of course means that everybody east of this corridor
is then responsible for basically everything else;
things like, oh,
defense, social services, foreign aid, the space program, the drug war,
and last but not least
paying off the
principal on the debt.

So let's take a look
at who's over here —
and at the size
of the country
that will actually
be footing this bill.

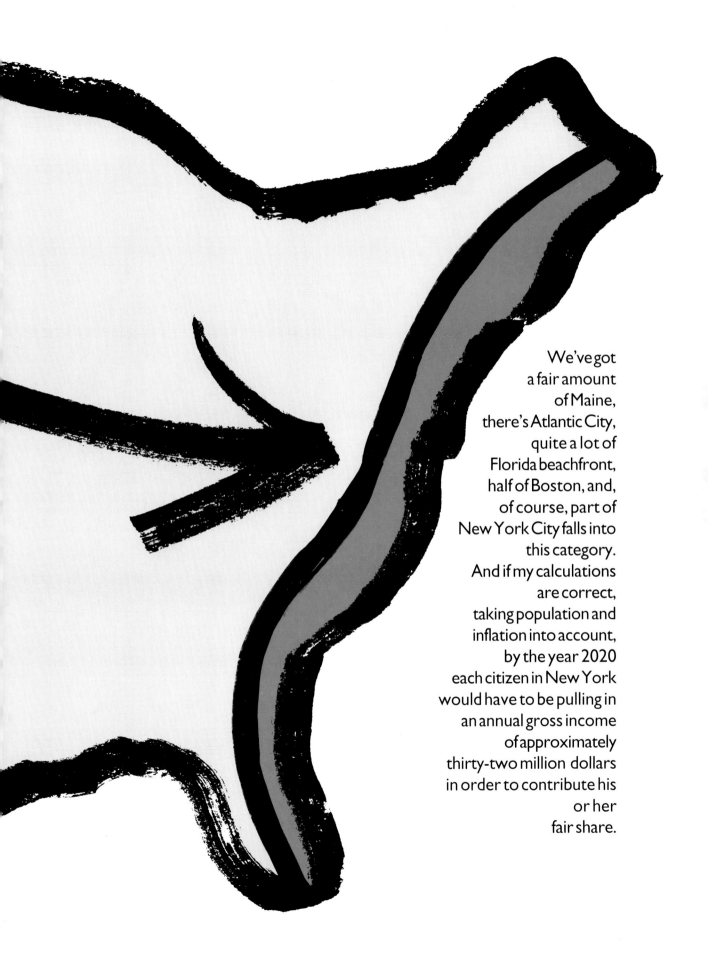

We've got
a fair amount
of Maine,
there's Atlantic City,
quite a lot of
Florida beachfront,
half of Boston, and,
of course, part of
New York City falls into
this category.
And if my calculations
are correct,
taking population and
inflation into account,
by the year 2020
each citizen in New York
would have to be pulling in
an annual gross income
of approximately
thirty-two million dollars
in order to contribute his
or her
fair share.

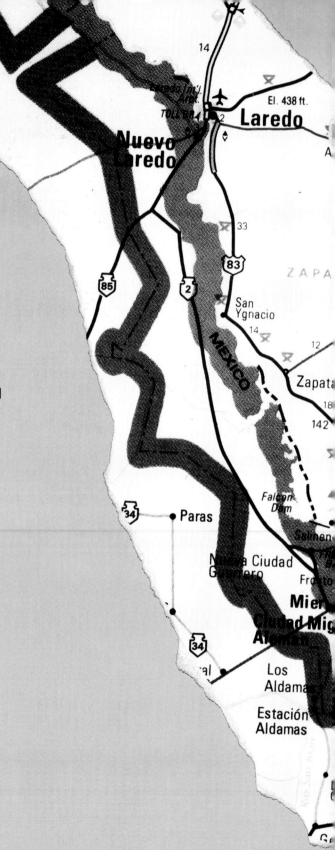

Pobre Mexico

Last time I was in Mexico,
I crossed the Rio Grande.
Now that's a crazy river.
It just keeps flooding
and changing course
and messing up all the maps.
And there's a sign posted
by the border that says:
**WILD RIVER —
REASONABLE MEN.**

Just to remind people to be philosophical
about how often the river moves
and property changes hands
and Mexico becomes America
and America, Mexico.

But the sign that should really be posted
at the border is
that old Mexican proverb,
the one that goes:

POBRE MÉJICO
TAN LEJOS DE DIOS
TAN CERCA DE LOS
ESTADOS UNIDOS

POOR MEXICO
SO FAR FROM GOD
SO CLOSE TO THE
UNITED STATES

Hiawatha

By the shores of Gitche Gumee.
By the shining Big-Sea-Water.
Downward through the evening twilight.
In the days that are forgotten.
From the land of sky blue waters.

And I said:
Hello operator. Get me Memphis, Tennessee.
And she said: I know who you're tryin to call, darlin.
And he's not home —
He's been away.
But you can hear him on the airwaves. He's howlin at the moon.
Yeah this is your country station and, Honey, this next one's
For you."

And all along the highways.
And under the big western sky,
They're singin oooo they're singin wild blue.
And way out on the prairies
And up in the high chaparral
They hear a voice it says: Good evening.
This is Captain Midnight speaking
And I've got a song for you.
Goes somethin like this.

Star light. Star bright. We're gonna hang some new stars
In the heavens tonight. They're gonna circle by day.
They're gonna fly by night.
We're goin sky high. Yoo hooooooooooooooooo
Yeah yoo hoo hooooooooooooo YoooooooooHooooo.

So good night ladies and good night gentlemen.
Keep those cards and letters coming.
And please don't call again.

Geronimo and little Nancy.
Marilyn and John F. dancing.
Uncle took the message and it's written on the wall.
These are pictures of the houses,
Shining in the midnight moonlight.
While the King sings "Love Me Tender."

And all along the watchtowers
And under the big western sky
They're singin Yoo hooooooooooooooo
Yoo hoooooooooooooooooooooo
And way way up there,
bursting in air,
Red rockets, bright red glare
From the land of sky blue waters
Sent by freedom's sons and daughters
We're singin Yoo Hooooooooooo
Yoo Hooooooooo

And dark behind it rose the forest
Rose the black and gloomy pine trees
Rose the firs with cones upon them.
And bright before it beat the water
Beat the clear and sunny water
Beat the shining Big-Sea-Water.
Oooo ooooo Ooooo oooooo

—INTERMISSION—

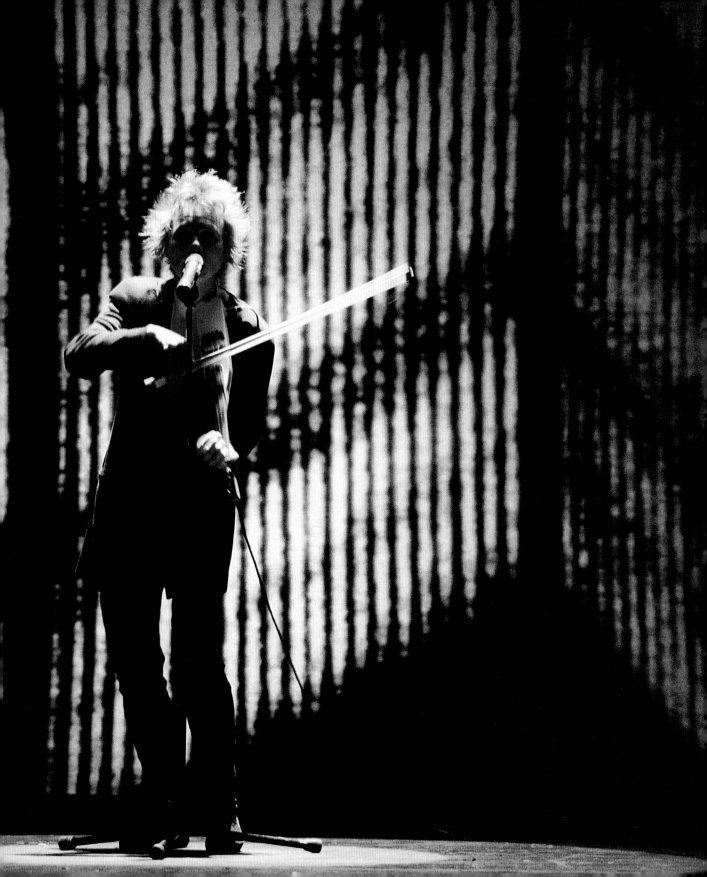

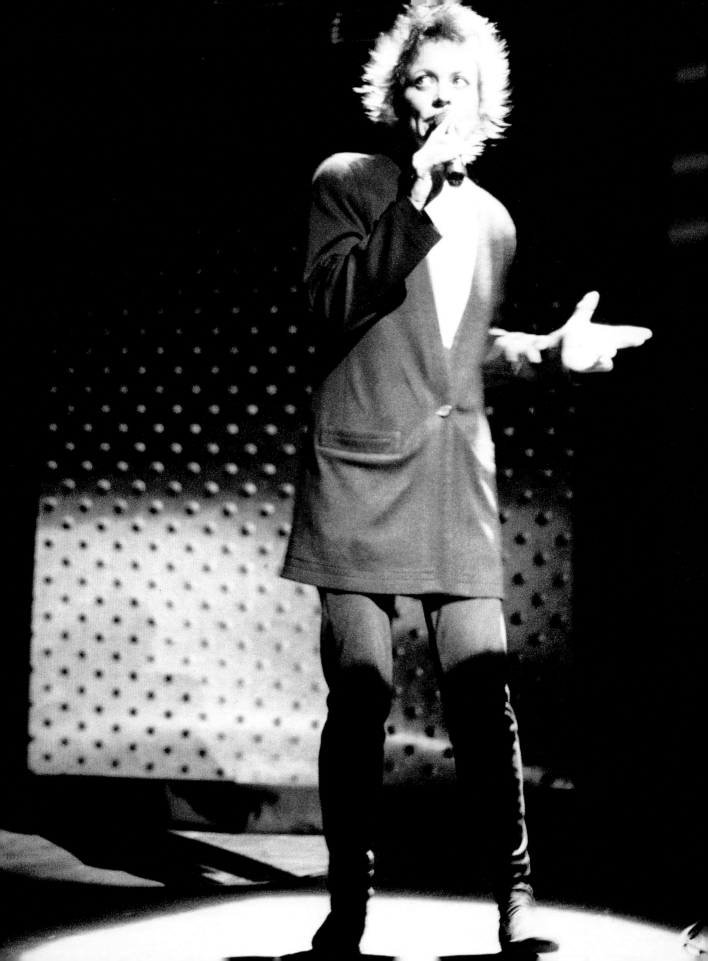

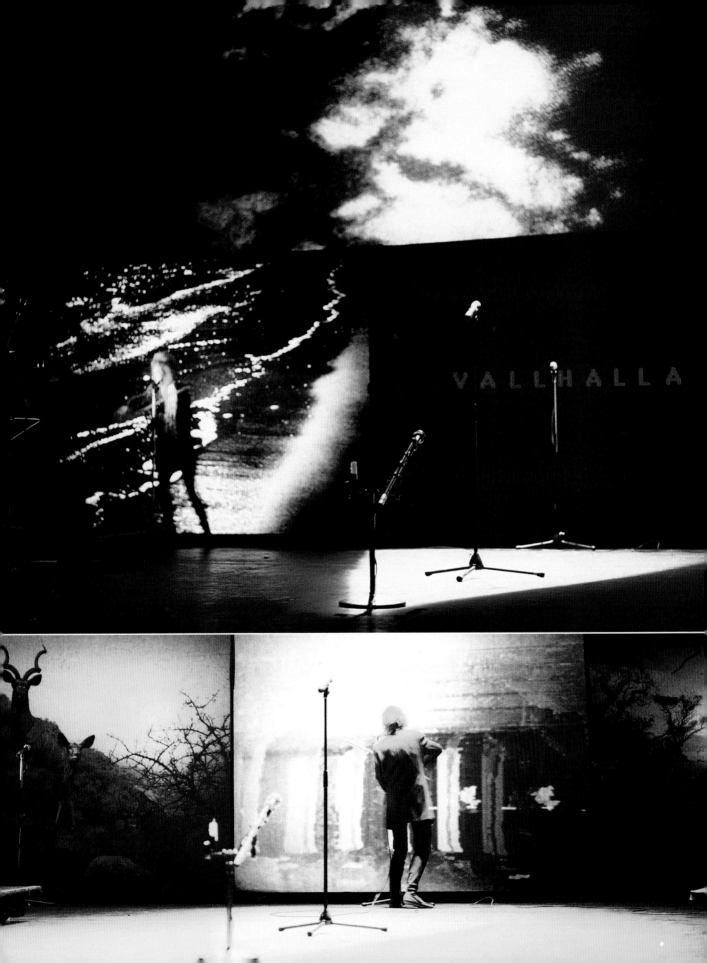

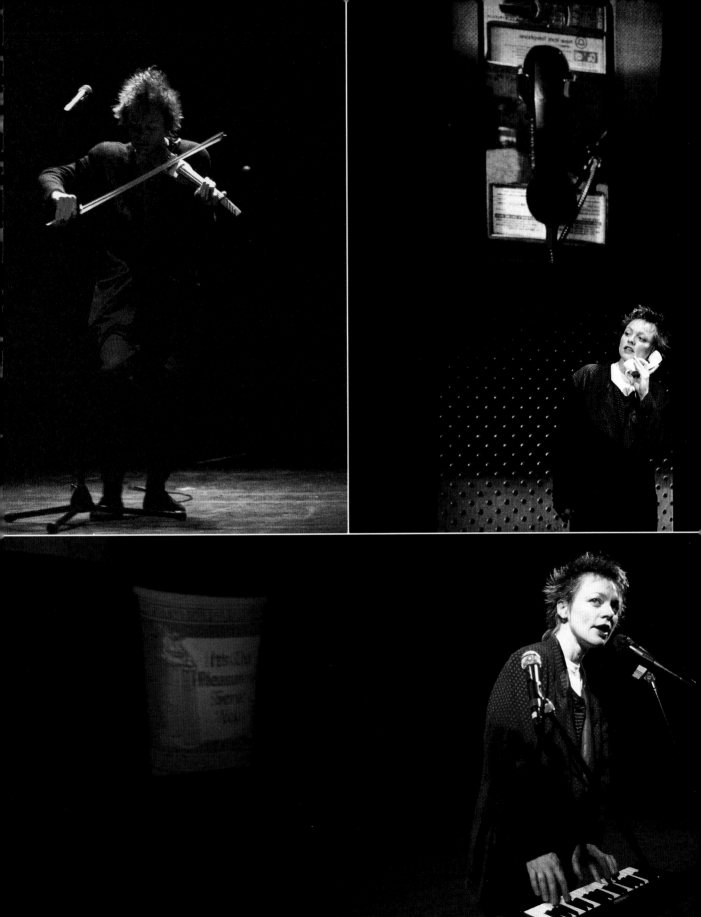

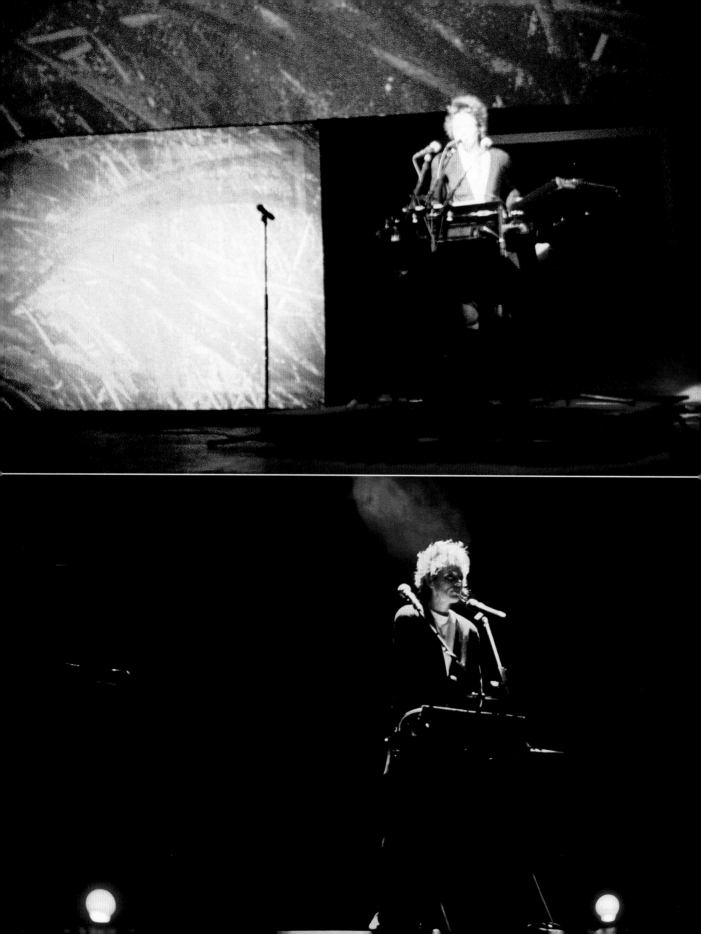

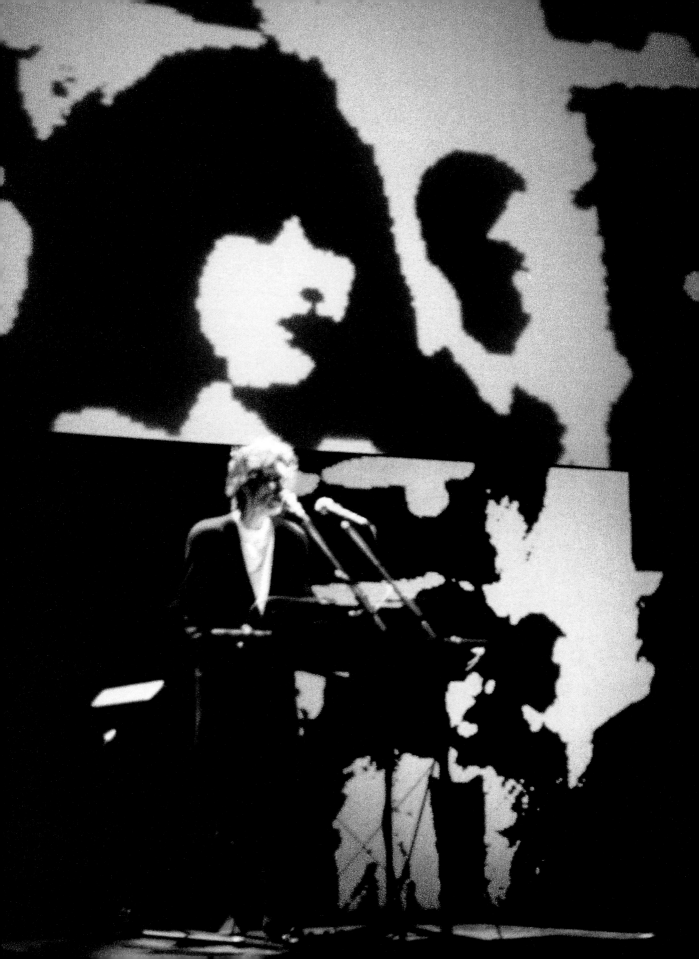

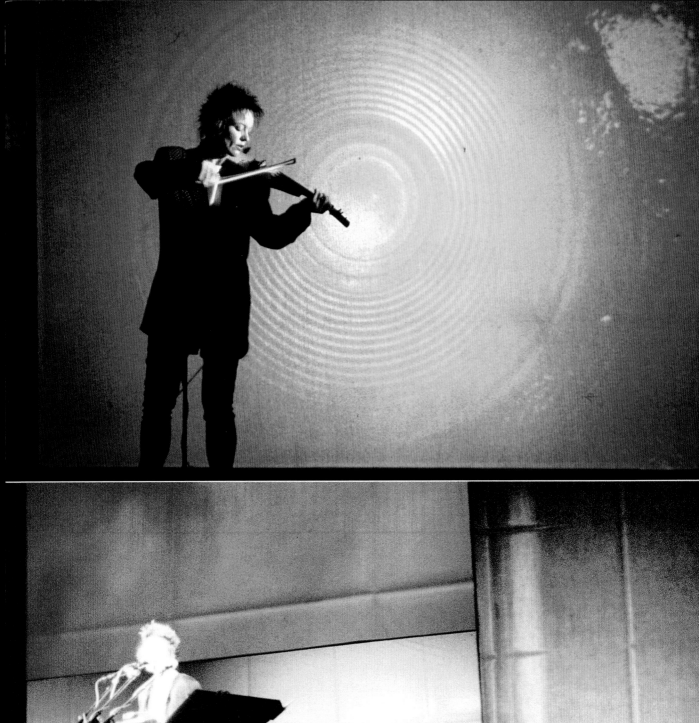
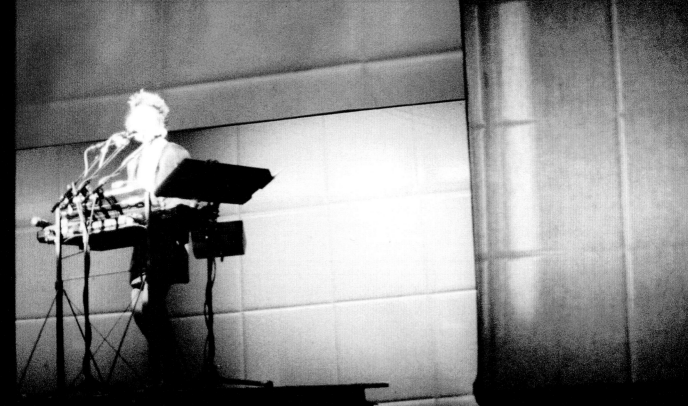

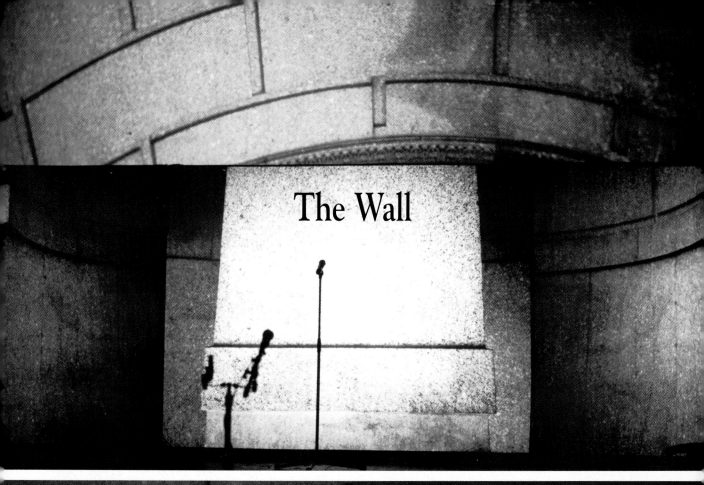

The Wall

Vor zweitausend Jahren,
war der stoizeste Satz,
den ein Mensch
sagen konnte der
"Ich bin ein Bürger Roms."
Heute, ist der stoizeste Satz,
den jemand
in der freien Welt
sagen kann
"Ich bin ein Berliner."

Two thousand years ago,
the proudest boast was
"I am a Roman."
Today, in the world
of freedom,
the proudest boast is
"I am a Berliner."

I'd like to
thank the translator
for interpreting my
German.

— John F. Kennedy, 1963

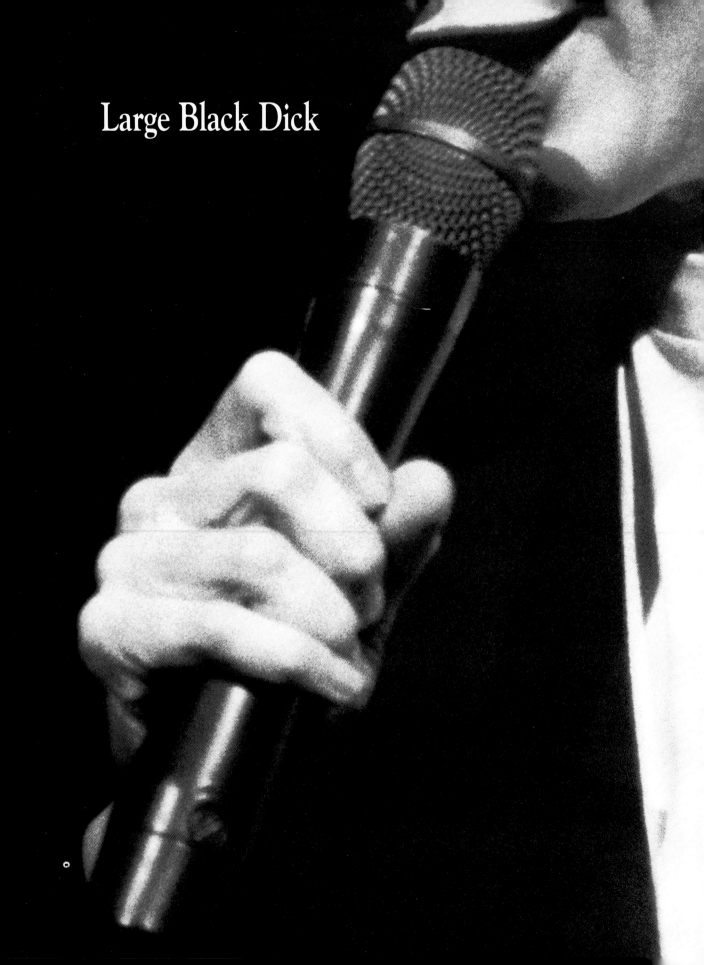

Large Black Dick

Let's talk about one of our hidden minorities:
American men — white American men.
I mean those get-out-of-town kind of guys,
like Senator Jesse Helms.
Washington, D.C.?
It was a town that wasn't big enough for the Senator
and the artist
Robert Mapplethorpe.

Yeah, the Senator liked pictures of snowy landscapes,
art that made you feel good.
And Robert Mapplethorpe?
He was after the big taboos, things like:
What do sex and religion
have in common?

So the Senator looked at the artist's photographs
and they were pictures of men
with no clothes.
And chains, black leather, and crosses.
But the picture that bothered the Senator the most
was a very large black dick sticking
out of a business suit.
So he made a law that said:

We're not going to look at this.
And you're not going to look at it, either.

You know I remember when I was a kid
sitting in church, and the preacher
would point to pictures of Jesus Christ
who was wearing no clothes and bleeding
profusely.
And the preacher was saying:
Love this man! Love his body!
He loves you!
And all the men and boys in church
were squirming around, they couldn't look,
they couldn't wait to get out of there.
This of course was the reason
for the invention
of Sunday afternoon
football.

Parade

Here come the little ones
Here come the crazy ones
Here come the ones they call the new Arabians.

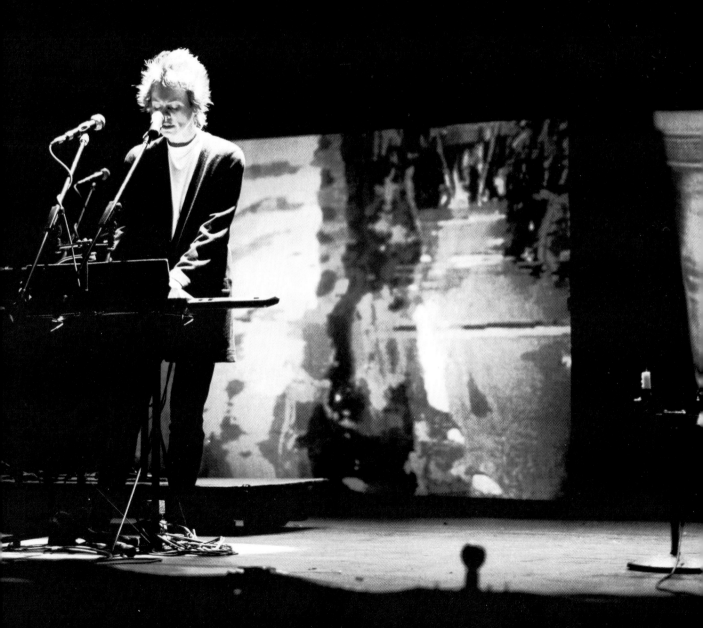

Here come all the bookworms
Here come the wireheads
Here come all the people in their pajamas.

Here come all the ex-wives
Here come the ex-marines
Here come a lot of guys
driving in their sex machines.

It's Our Pleasure to Serve You

It's Our Pleasure Serve You

Listen, Honey...

The last parade I was in was a big demonstration
at the Playboy Bunny Club in New York City.
This was a big media event, lots of TV cameras,
and my role was to explain to the press
exactly what we were doing there.

So we're marching around with these big signs
and once in a while we'd halt and I'd explain to the reporters
that we were marching to protest
the way women were being economically exploited like animals.
And I had drawn up some pamphlets to illustrate this:
pictures of chicks and bunnies
and foxes and pussycats and other animals
that had come to symbolize women
and I was handing them out.

So anyway, we're marching around the club and this woman,
one of the bunnies,
was just getting to work and she said:
"So, uh hey! What's going on here?"

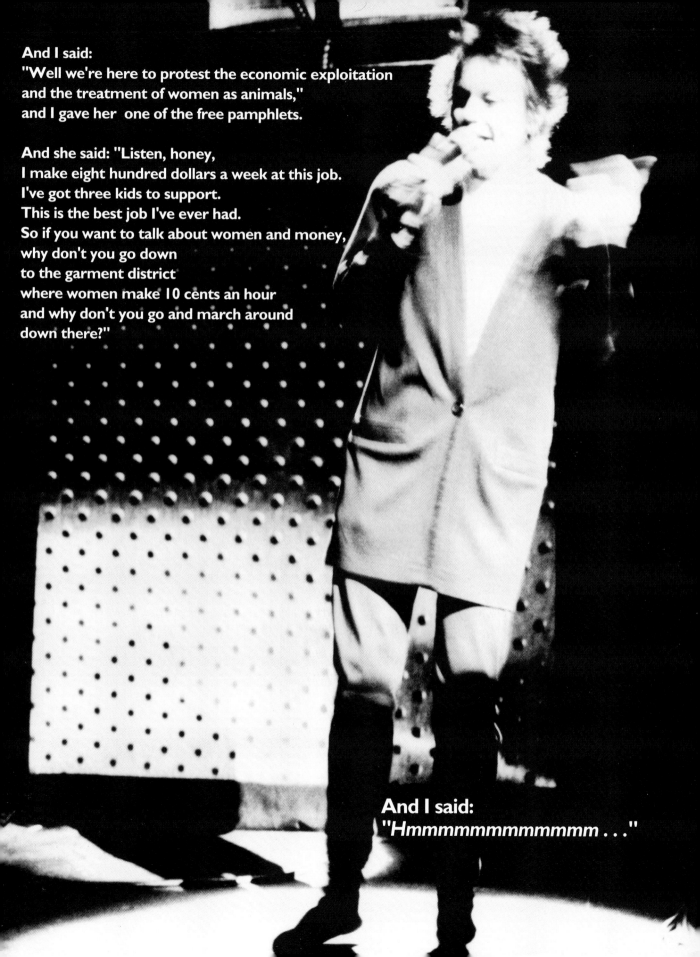

And I said:
"Well we're here to protest the economic exploitation
and the treatment of women as animals,"
and I gave her one of the free pamphlets.

And she said: "Listen, honey,
I make eight hundred dollars a week at this job.
I've got three kids to support.
This is the best job I've ever had.
So if you want to talk about women and money,
why don't you go down
to the garment district
where women make 10 cents an hour
and why don't you go and march around
down there?"

And I said:
"Hmmmmmmmmmmmm . . ."

Well I was in the ladies room
down at the terminal
and there was graffiti all over the stalls.
One said in elaborate curlicue writing:
> I LIKE GRILS.

This was crossed out and someone
had written below:
> You mean **GIRLS** don't you?

This had also been crossed out and someone
had written below:
> No, I mean **GRILS**.

I like ~~Grils~~

~~YOU MEAN GIRLS, DON'T YOU?~~

No, I mean Grils!

Beautiful Red Dress

Well I was down at the Zig Zag.
That's the Zig Zag Bar & Grill.
And everybody was talking at once and it was getting
real shrill.
And I've been around the block but I don't care
I'm on a roll
I'm on a wild ride.
'Cuz the moon is full and look out, baby —
It's high tide.

I've got a **beautiful red dress**.
And you'd look really good standing beside it.
I've got some beautiful new red shoes
and they look so fine.
I've got a hundred and five fever and it's
high tide.

Well just the other day I won the lottery
I mean *lots* of money.
I got so excited I ran into my place and I said:
HEY!!!! IS ANYBODY HOME???
Nobody answered but I guess that's not too weird,
since I live
alone.

I've got a **beautiful red dress**.
And you'd look really good standing beside it.
GIRLS?
We can take it and if we can't —
we're gonna fake it.
We're gonna save ourselves. Save ourselves.
We're gonna make it and if we don't —
we're gonna take it.
We're gonna save ourselves. Save ourselves.

Well they say women shouldn't be the president
'Cuz we go crazy from time to time.
Well push my button, baby,
here I come.
Yeah look out, baby, I'm at
high tide.

I've got a **beautiful red dress**
and you'd look really good standing beside it.
I've got a little jug of red sangria wine
and we could take little sips
from time to time.
I've got some bright red drop-dead lips
I've got a little red car and mechanical hips
I've got a hundred and five fever!

OK OK!!! Hold it!
I just want to say something.

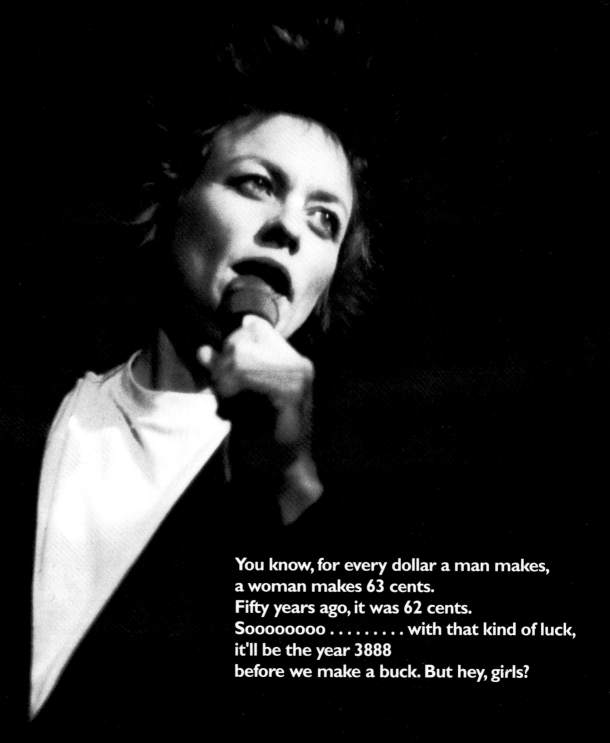

You know, for every dollar a man makes,
a woman makes 63 cents.
Fifty years ago, it was 62 cents.
Soooooooo with that kind of luck,
it'll be the year 3888
before we make a buck. But hey, girls?

We can take it and if we can't—
we're gonna fake it.
We're gonna save ourselves. Save ourselves.
(Yeah tell it to the judge)
We're gonna make it and if we don't—
we're gonna take it.
We're gonna save ourselves. Save ourselves.
We've got a fever of a hundred and five
and the moon is full
and look out, baby, it's high tide.

Well I could just go on and on . . .

But tonight

I've got a headache.

Shadow Box

Should the unborn have civil rights?
Yes, Because they can thank you later,

Should the dead have civil rights,
No. Because they can't talk anymore.

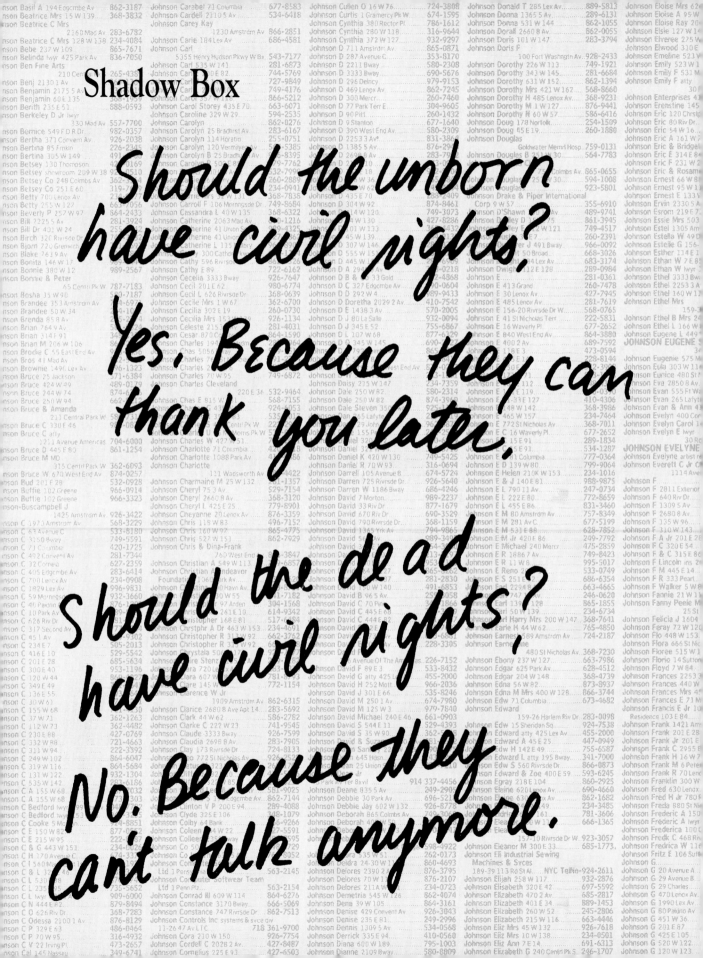

goner

loser

successful
head transplant

Last Night

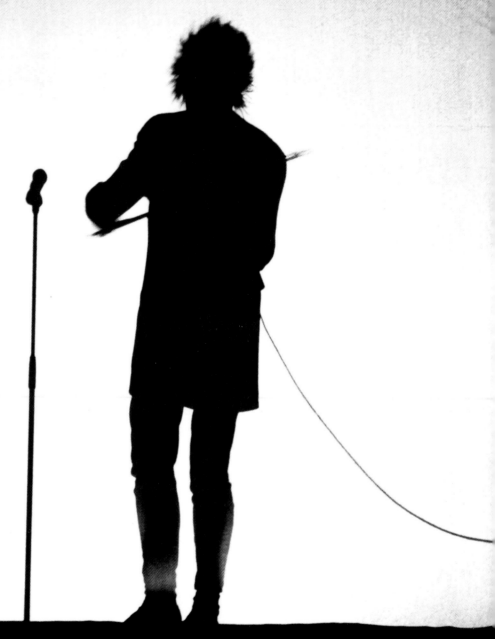

Last night I dreamed I died and that my life had been
rearranged into some kind of
theme park.
And all my friends were walking up and down the boardwalk.
And my dead grandmother was selling cotton candy

And there was this huge Ferris wheel
about half a mile out in the ocean,
half in and half out
of the water.

And all my old boyfriends
were on it,
with their new girlfriends.
And the boys were waving and shouting
and the girls were saying:
"Eeeeeeek!"

Then they disappear under the surface
of the water and when they come up again
they're laughing and gasping for breath.

83

John Lilly, the guy who says he can talk to dolphins, said
he was in an aquarium and he was talking to a big whale
who was swimming around and around in his tank.
And the whale was asking him questions,
telepathically.
And one of the questions
the whale kept asking was:

"DO ALL OCEANS
HAVE
WALLS?"

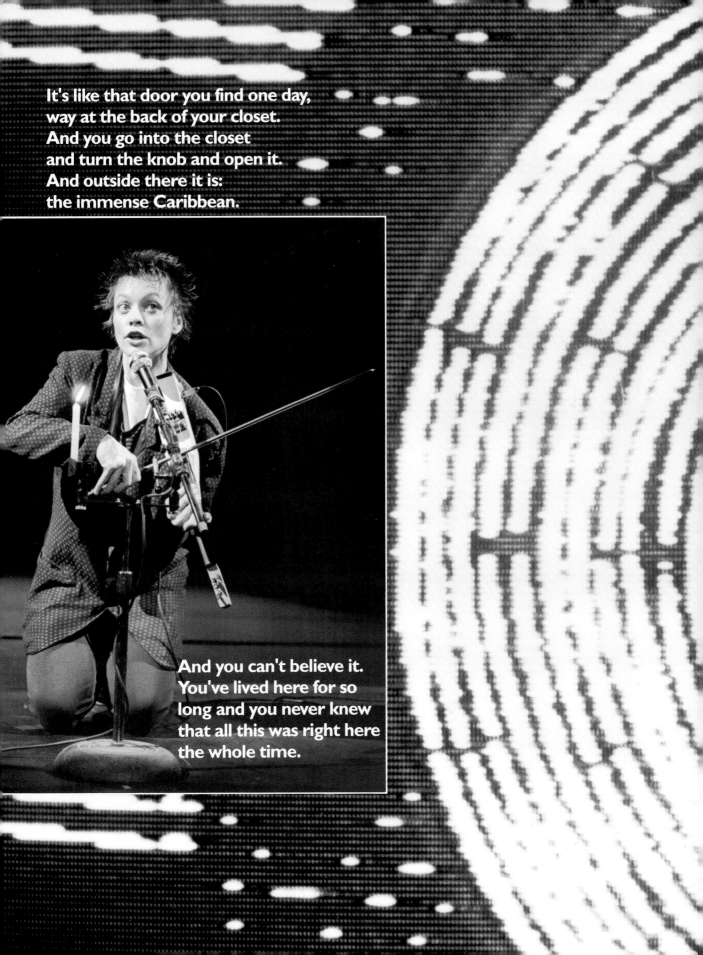

It's like that door you find one day,
way at the back of your closet.
And you go into the closet
and turn the knob and open it.
And outside there it is:
the immense Caribbean.

And you can't believe it.
You've lived here for so
long and you never knew
that all this was right here
the whole time.

Strange Angels

They say that heaven is like
TV: a perfect little world
that doesn't really need you.
And everything there is made of light.
And the days keep going by
Here they come. Here they come.
Here they come.

Well it was one of those days, larger than life,
when your friends came to dinner
and they stayed the night.
Then they cleaned out the refrigerator. They ate everything in sight.
And then they stayed up in the living room
and they cried all night.

Strange angels. Singin just for me.
Old stories, they're hauntin me
This is nothing
Like I thought it would be.

Well I was out in my four-door
with the top down
And I looked up and there they were:
Millions of tiny teardrops
just sort of hanging there.
And I didn't know whether to laugh or cry.
And I said to myself:
What next, big sky?

Strange angels. Singin just for me
Their spare change falls on top of me.
Rain falling — falling all over me.
All over me.
Strange angels. Singin just for me.
Old stories — they're hauntin me.
Rain falling. Falling all over me.
All over me.

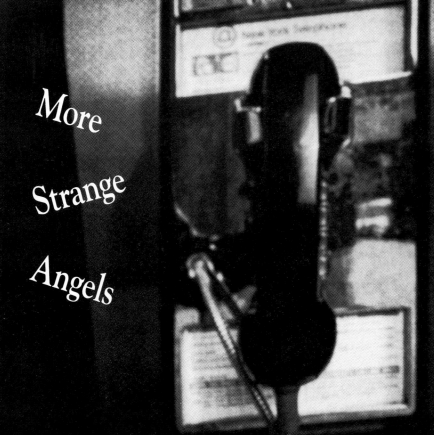

More

Strange

Angels

You know what I've always liked
about **Superman**,
it's that his alter ego
was a newspaperman.
No matter where **Superman** was,
there was always a phone booth
and **Clark Kent** could call it in.

"Hello. Kent here! Yeah . . . listen,
there's been a gravity failure.
You heard me! Gravity failure!

And uh, things have just started floating up.
Yeah, well of course Superman was there.
I can see him from here."

Statue of Elvis

Stunned Scientists are trying to make sense out of the most extraordinary ~~space exploration history~~

discovery in space exploration history— a statue of the rock 'n' roll king that's been found on the surface of Mars!

This headline is from a newspaper clipping... The ...

...like image of Elvis Presley" about eight feet tall. It was discovered in "an isolated area of the red planet".

The article quotes a UFOlogist named Nikola Stanislaw as saying, "The only explanation is the statue was put there by extraterrestrials who think the rock star is some kind of a god on Earth."

...probe approached the statue, it was ...ed by the familiar rock and...

roll favorite *All Shook Up*. It is speculated that the space creatures thought this was a proper fanfa... ...eaceful relationship with Ear... visitors.

The UFO experts had a number of othe... proposed explainations. One of them: that cel ebrations of Elvis Presley throughout the world may have given the aliens these ideas.

The writing on a plaque beneath the statue is being studied and may give a clue as to whether the aliens thought that Elvis was one of our Gods or Kings and why the extra terrestrials intended by leaving this larger-than-life sized statue of Elvis Presley on Mars...

Photos of the statue were beamed back to Earth

found on Mars

When Elvis got out of the army and
came back to the United States, he kept saying,
"Man! It's so different here!
Seems like I've been in Germany for ten years."
The reporters kept asking him:
"So, Elvis, what's it gonna be like for you
when things get back to normal?"
And Elvis said:
"Listen, when things get back to normal,
I'll be driving a truck."

95

Brilliant Pebbles

You know, I can't believe all this equipment
is still actually working.
There are literally thousands of things
that could go wrong with it.
It really makes me wonder how the military
could be so confident
in *their* systems,
which have thousands of times
more potential for
error. Take the newly unveiled defense program,
the so-called
Brilliant Pebbles.
Now first, about this name, which you have to say
sounds like something Maxwell Smart might have said
into his shoe.
But at least this time you can pronounce it, unlike
"Strategic Defense Initiative."

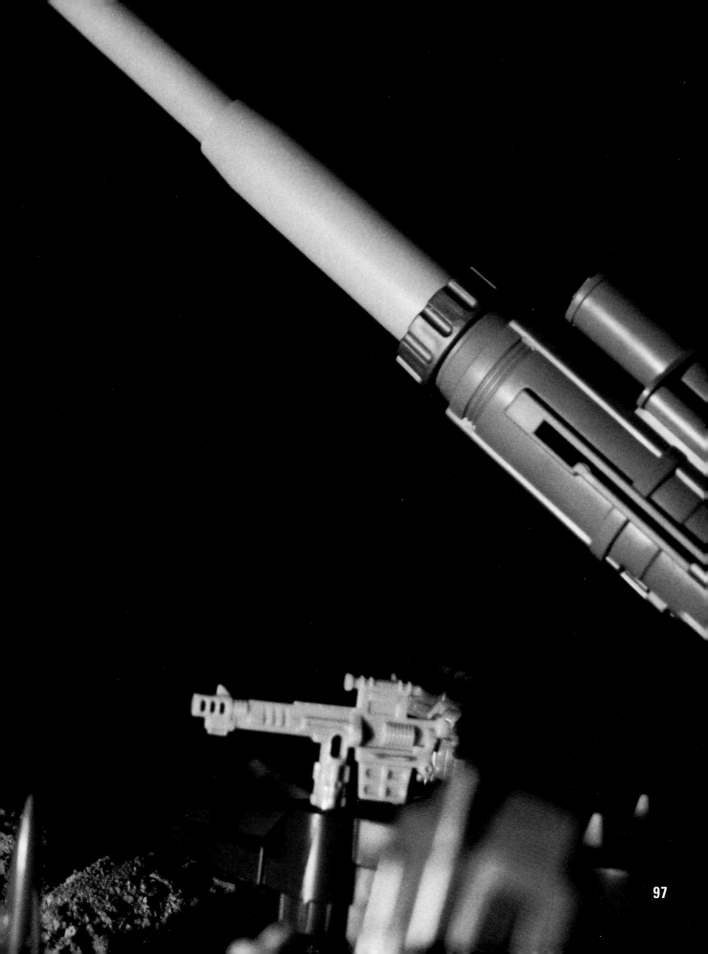

Now the idea of Brilliant Pebbles is this:

Launch several hundred thousand

light-seeking, kamikaze computers

mingle with the rest of the high

the pack mentality takes over and

huge incoming

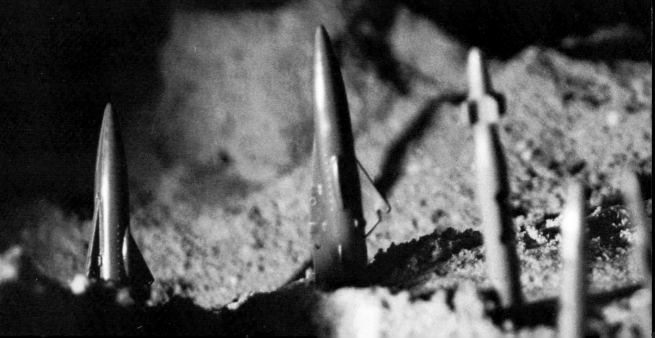

100-pound, 3-foot long, "smart,"

into low orbit. And they sort of

traffic and whenever they see fire,

they all just start bashing into these

enemy missiles.

Or that's the idea anyway.

Recently though, some of the military research
has concentrated on the study of nature
rather than technology.

When the army was trying to build a six-legged robot
that could walk on the moon, they were having a lot of design problems.

So they decided:

"HEY! Let's look at insects!
They've got six legs.
Let's see how they do it!"

So they spent an enormous amount of money on this research
and what they discovered was that six-legged insects
can barely walk. They're constantly tipping over
and tripping over their legs
and breaking them off.
But like all military research that goes billions over budget,
they keep reminding you:

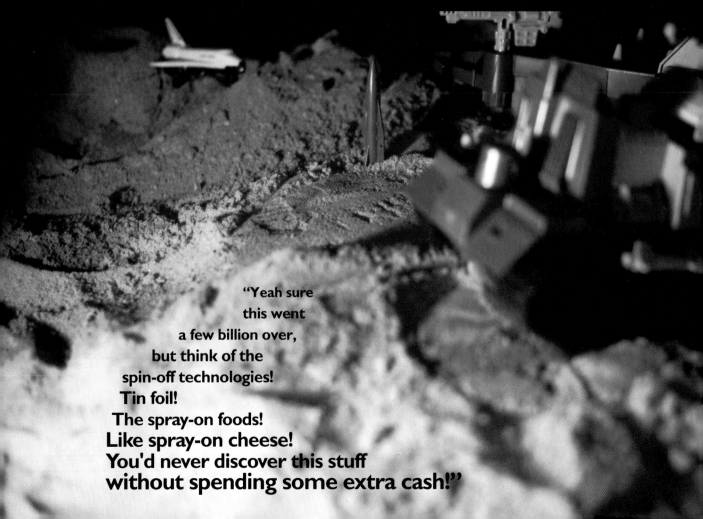

"Yeah sure
this went
a few billion over,
but think of the
spin-off technologies!
Tin foil!
The spray-on foods!
Like spray-on cheese!
You'd never discover this stuff
without spending some extra cash!"

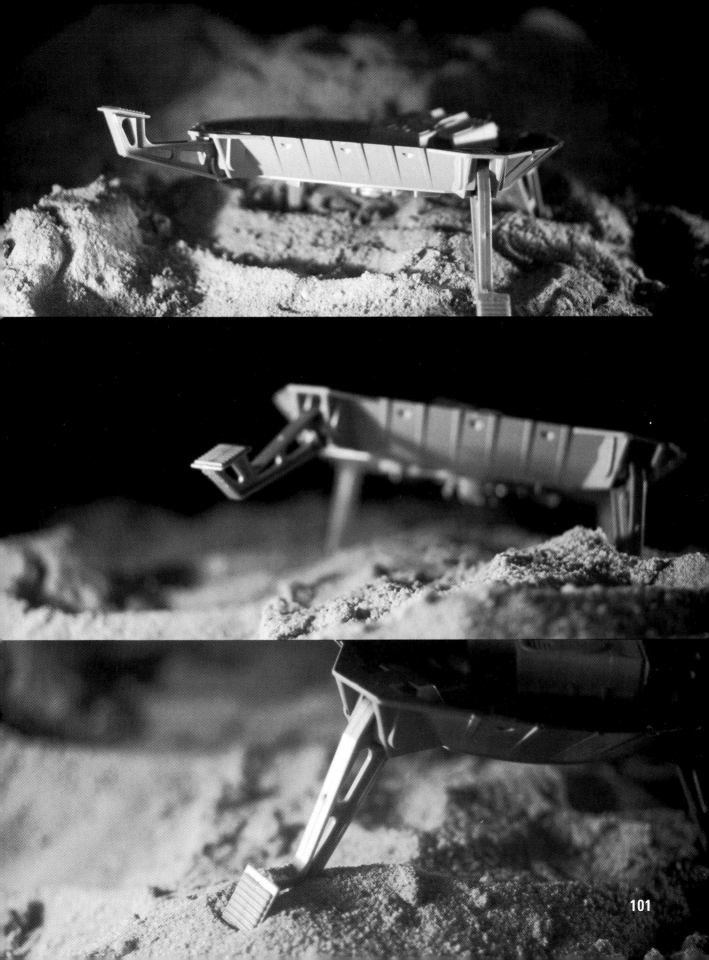

One of the most ambitious spin-offs is a company in Florida
that has been advertising near the obituary columns.
For a rather large fee, you can rent space in a capsule
and they take your ashes and
launch them up into low orbit.

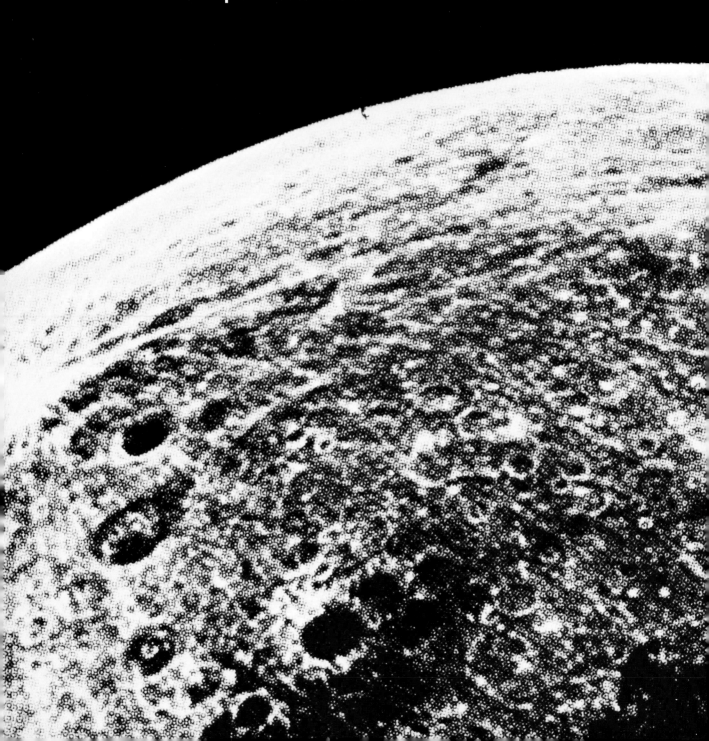

Yeah, you can spin around forever up there
with the rest of those loose wrenches.
That is until the day some astronaut drives by
and your capsule smashes right into his windshield,
like a bug
on a hot summer highway.

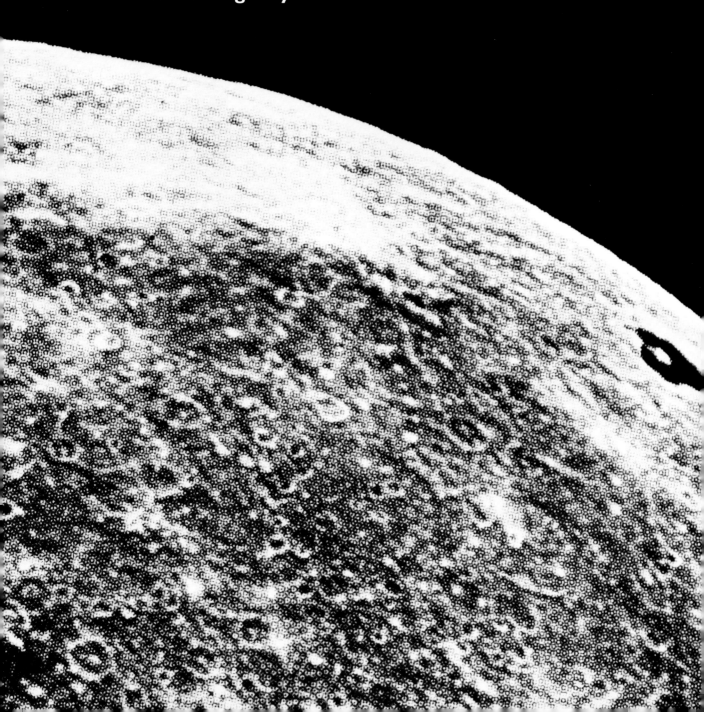

RAMON

Last night I saw a host of angels
and they were all singing different songs.
And it sounded like a lot of lawn mowers
Mowing down my lawn.

And up above kerjillions of stars
spangled all over the sky
And they were spirals turning
Turning in the deep blue night.

And suddenly for no reason
the way that angels leave the ground
They left in a kind of vortex
Traveling at the speed of sound.

And just as I started to leave,
Just as I turned to go,
I saw a man who'd fallen
He was lying on his back in the snow.

Some people walk on water.
Some people walk on broken glass.
Some just walk round and round
in their dreams
Some just keep falling down.

So when you see a man who's broken
Pick him up and carry him.
And when you see a woman who's broken
Put her all into your arms.
 Cuz we don't know where we come from.
We don't know what we are.

And you? You're no one.
And you? You're falling.
And you? You're traveling.
Traveling at the speed of light.

And you? You're no one.
And you? You're falling.
And you? You're traveling.
Traveling at the speed of light.

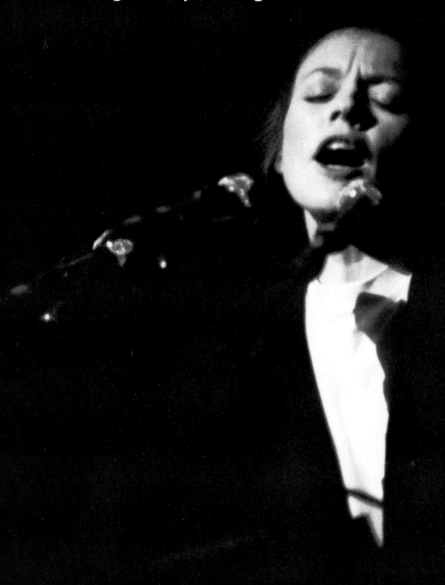

Falling

A couple of months ago I was getting out of a cab
and I turned around and fell right down
into an open manhole.
Yeah, right into the New York City
sewer system.

And when I was down there, I looked around
and said to myself:
This is exactly like one of my songs!
And then after I'd been down there
a little longer
I thought:
No, it's not.

So the ambulance took me to the hospital
and parked my wheelchair in the emergency room.
And I sat there watching this long line of misery
passing by. Gunshot wounds, stabbing victims,
and as the night wore on,
the old people started to come in.

And there was this old woman sitting next to me.
She was a bum and her feet were bleeding
and swollen up like grapefruits
and she kept saying:
"Look at my feet! Look at my feet!"
And I couldn't.

And there was an old man sitting on the other side of her
and she kept saying:
"My feet. Look at my feet!"
And he did.
And he said:
"That must really hurt."

This evening's performance is dedicated to
Abbie Hoffman, the man who shouted "Theater!"
in a crowded fire.

About *Empty Places*

Like many people, I slept through the Reagan Era politically. When I woke up, everything looked really different. Homeless men and women were living on the streets of New York, hundreds of thousands of Americans were dead or dying of AIDS, and the national mood was characterized by fear, intolerance, and straight-ahead greed. Suddenly everything seemed deeply unfamiliar. Was this really my country? I decided to write about this new place, not because I had any solutions, but because I needed to understand how and why things had changed.

Empty Places begins with hundreds of images of New York City which I shot at night. I loved going on these night excursions — just me with a 35mm camera and tripod. My beat was mostly downtown: empty warehouses, bombed-out buildings, abandoned car lots gleaming in eerie dim streetlights. Shark light. I didn't shoot people even when I found them.

It took two years to complete *Empty Places*. Eventually, I shot thousands of slides and dozens of films. Computer animations and digital processing gave the visuals a stark and somewhat "removed" look. Some of the songs from the album *Strange Angels* were included in the performance, although the live versions were completely different. Using MIDI keyboards, hopped-up violins, and voice-processing electronics, I found that one person can make a lot of noise.

I wanted to tour with *Empty Places* because I like the energy created by people gathered in one large space. Storytelling has always been about people huddling around a fire. To me, electronics has the mystery and power of fire, and basically my method is to drag a lot of equipment usually used in recording studios or visual post-production houses out onto a stage. Of course this equipment has a tendency to blow up or malfunction, but, fortunately, I like the excitement of things going wrong. It's my only chance, in a highly technological situation, to improvise.

Touring with large shows like this one has been sort of outmoded lately. It's difficult and expensive to move people and equipment around — much easier to make a video and just ship it out. But the experience of presenting this work, especially in Eastern Europe, reminded me that theater is still a powerful and direct way to make contact.

The *Empty Places* tour had seventeen people on the crew and two huge trucks for projection, lights, and sound.

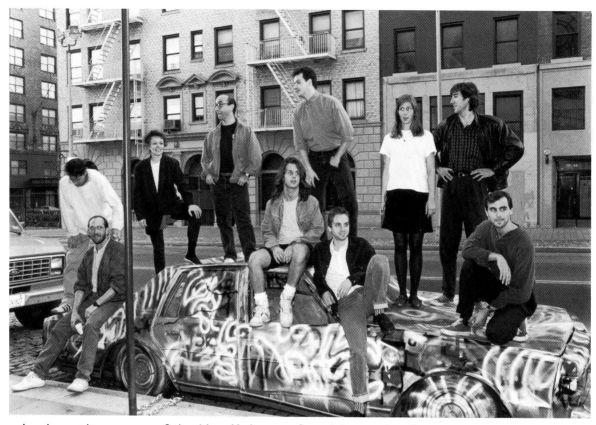

In above photo, some of the New York crew from left to right: Gregory Meeh, Jerry Marshall, Laurie Anderson, Rob Brenner, Robin Danar, Kevin Moore, Steve Cohen, Vicky Meyer, Fraser Bresnahan, and Miles Green.

In New York and Los Angeles, we parked a battered, graffiti-decorated car that we got from the junk yard in front of the theater as a kind of marquee. Tapes from the record *Strange Angels* blared out from a boom box under the back seat.

The set for *Empty Places* consisted of two twenty-foot projection towers on either side of the stage and three movable units in the center. These structures were covered with screens for rear projection. Forty-five slide and film projectors were located in the structures and controlled by one image computer. In addition there were projectors from front-of-house positions for a large screen hung at the back of the stage. After several weeks on the road we were able to get the entire system running in just a few hours. Load-out was, of course, even faster.

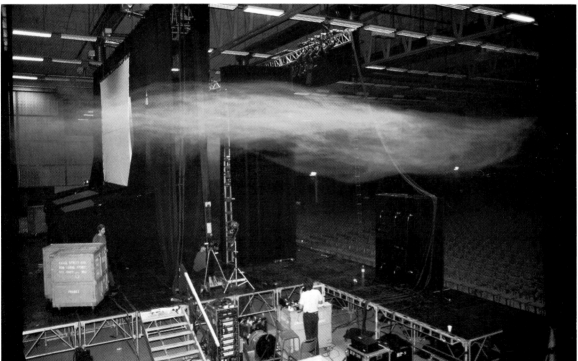

Above: The twenty-foot projection towers. *Below: Testing the smoke machine.*

Fraser Bresnahan *(right)*, who program-
med the slides for the computer, used
several different versions based on the
configurations of the theaters. A video
camera in the house was fed to a monitor
at the offstage right position so the visual
crew could watch for any problems and
coordinate with the live action.

Vicky Meyer *(left)* operated the film during
the show as well as continually editing and
replacing films as they became scratched
or torn.

Miles Green (above) controlled the MIDI system offstage left. Clearcom communication among the crew members was the only way to hit the hundreds of cues.

The crew traveled mostly by bus. Each member had a tiny bunk and shared the common kitchen, bathroom, dining room, and video area.

The tour included fifty cities in the United States and Canada, thirty-three in Europe, and one five-concert series in South America.

The bus is loaded onto a ferry to Sweden.

Press conferences were a mixture of art and politics. Especially in Europe, where typical questions included: Doesn't your government object to your being so critical? (No. Free speech, etc.) Of course, there's always the reporter who concentrates on things like: Do you really cut your own hair?

Tour manager Rob Brenner with two members of Yugoslavian security.

Security was noticeably tighter in Eastern European countries. Some of the performances were done in sports halls, where sometimes the dressing rooms were filled with barbells.

Press conference in Greece.

Radio interview in Yugoslavia.

Lucerna Hall Foyer.

Lucerna Hall, Prague.

Two members of the custodial team in Budapest.

In Prague we performed in a theater designed by Vaclav Havel's grandfather *(see pedestal, opposite above)*. We were unable to load-in until the last minute, because a class in ballroom dancing for teenagers was in progress *(opposite below)*. It was especially thrilling to perform in Eastern Europe because the audiences were so talkative and open.

Empty Places was super-titled in a total of ten different languages. For example, "Ponekad zazelim do nomon" is Serbo-Croatian for "Sometimes I wish I hadn't gotten that tattoo." Because I occasionally sang short sections of the concert in the local language, members of the staff would think I actually spoke it and would tell me what seemed to be long, involved stories before I could signal them that I didn't actually speak or understand Serbo-Croatian.

Fans in London.

Even though the backstage door scene is sort of corny, signing autographs on some-one's arm, etc., I'm very grateful to people who take the time to talk to me after a performance. Sometimes they tell me, "Oh, I got so many ideas from your work!" Then they tell me what the ideas were and they have nothing whatsoever to do with what I said or did. This tells me that the work was really a success — when other people take it and use it in a way I'd never dreamed of.

The *Empty Places* Tour

The *Empty Places* tour premiered in Charleston, South Carolina, at the Spoleto Festival on June 8, 1989. The New York premier took place at the Brooklyn Academy of Music on October 3, 1989.

Dates		City	Dates	City
June 8-11	**1989**	Charleston	May 2 & 3	Austin
October 3-15		New York	May 4	San Antonio
February 6	**1990**	Albuquerque	May 5	Houston
February 7		Phoenix	May 7	New Orleans
February 8		Monterey	May 9 & 10	Cincinnati
February 10-14		Los Angeles	May 12	Schenectady
February 15-17		San Diego	May 14	Baltimore
February 17 & 18		San Francisco	May 15	New Brunswick, NJ
February 20		Seattle	September 13-17	Bueno Aires, S.A.
February 21		Vancouver	October 25	Freiburg
February 22		Portland	October 27	Munich
February 25		Boulder	October 28	Düsseldorf
February 27		Minneapolis	October 29	Hamburg
March 1		Bloomington	October 31	Frankfurt
March 2		Champaigne	November 2	Vienna
March 3		Milwaukee	November 7	Rome
March 4		Madison	November 8	Bari
March 5 & 11		Chicago	November 9	Naples
March 7		Columbus	November 10	Turin
March 8 & 9		Detroit	November 11	Florence
March 10		Ann Arbor	November 13	Barcelona
March 12		Iowa City	November 14	Madrid
March 14		Cleveland	November 15	Zaragrosa
March 15		Pittsburgh	November 16	Gijon
March 16 & 17		Washington	November 17	St. Sebastian
March 21-23		Montreal	November 19	Zurich
March 24		Ottawa	November 20	Paris
March 26		Toronto	November 22	Berlin
March 29		Quebec City	November 25 & 26	London
March 31		Boston	November 29	Copenhagen
April 2		Burlington	November 30	Oslo
April 3		Northhampton, MA	December 1	Stockholm
April 4		New Haven	December 3	Brussels
April 5		Philadelphia	December 4	The Hague
April 12-14		New York	December 5 & 6	Lille
April 18		Lawrence, KS	December 9	Prague
April 19		Kansas City	December 10	Budapest
April 20 & 21		St. Louis	December 11	Belgrade
April 23		Corpus Christi	December 12	Zagreb
April 24 & 25		Dallas	December 13	Ljubiana
April 27		Nashville	December 17	Thessolonike
April 28 & 29		Atlanta	December 18	Athens

Empty Places was created with funds provided in part by the Brooklyn Academy of Music NEXT WAVE Festival.

Empty Places Tour Credits

Words, Music and Visuals:	Laurie Anderson
Production Manager:	Rob Brenner
Visual Director:	Perry Hoberman
Visual Programmer and Computer Operator:	Fraser Bresnahan
Film Editor and Projectionist:	Vicky Meyer
Assistant Projectionist and Carpenter:	Kevin Moore
Lighting Designer:	Richard Nelson
Audio Design:	Bob Bielecki and Eric Liljestrand
House Audio Engineer:	Robin Danar
MIDI Engineer:	Miles Green
Technical Consultant:	Gregory Meeh
Additional 16mm Photography:	Eddie Marritz
Design Consultant:	George Tsipin
Master Carpenter:	Jerry Marshall
Production Assistant:	Ramon Diaz
Executive Producer:	Linda Goldstein
Management Coordinator:	Steve Cohen

Empty Places Book Photo Credits

Tim Jarvis: Pages 6, 7, 8, 11, 18, 19, 20, 22/ 23, 26/27, 28, 31, 33, 34, 43, 44, 48, 49, 54, 55, 56, 58/59, 61, 63, 64 both, 65 top left, 66 both, 67, 68 bottom, 69, 70, 73, 77, 82, 83, 86, 87, 90, 110, 111 and 119 both.
Ebet Roberts: Pages14/15 all , 51, 62 both, 68 top, 116, 118, 120 top and 121
Martha Swope Associates / Linda Alaniz: Pages 74, 89 and 94
Martha Swope Associates / William Gibson: Page 65 top right and bottom.
Laurie Anderson: All other photos.